THE HOME DARKROOM

THE HOME DARKROOM

by
MARK B. FINEMAN

AMPHOTO

American Photographic Book Publishing Company, Inc.
Garden City, New York

CONTENTS

This book is directed to the amateur photographer who plans to do most of his darkroom work in an improvised setting, such as the kitchen, bathroom, or spare room. Even if you expect to have a permanent darkroom arrangement, this book will probably be of value because it is a detailed, step-by-step guide to photographic technique, with as much unexplained jargon and photographic baloney removed as possible. It is strange, in fact, that of all the books currently available to the part-time photographer, few seem capable of explaining anything in a direct, uncomplicated fashion. One of my aims is to correct this state-of-affairs.

What sort of person might find this book worthwhile? I was prompted to write the book at the urging of friends whose interest in photography was recent, and who had grown unhappy with the results of drugstore processing. Like them you may harbor the desire to be a bit more creative and to have greater control over the end-product.

I will assume that you own a halfway decent camera, probably a 35mm single-lens reflex or viewfinder camera, but possibly a twin-lens reflex. It doesn't have to be anything great; it need only have a focusing arrangement and a way to vary the amount of light entering the lens. The latter feature refers to those baffling f/numbers or "stops," usually indicated around the barrel of the lens. If your camera is an inexpensive, fixed-focus type, such as an *Instamatic,* it is better if you send the film to the drugstore than process it yourself.

I haven't placed a great deal of emphasis on the cost of the camera for a very simple reason: photographs are created primarily by the eye and brain, not by the camera. A camera is only needed to preserve a record of what you see. This point is both confusing and frequently overlooked by the amateur, because he tends to think that by spending $300 on a camera he will automatically obtain better pictures than if he had settled for a $75 model. What frequently happens is that both affluent and less well-to-do photographers create equally mediocre pictures desipte differences in equipment. In order to make an outstanding

photograph, there must still be some creative "magic" within the individual, which no amount of equipment or training can implant. On the other hand, there is no point in ruining a photograph you find acceptable simply because you don't have the skills necessary to produce an outstanding one.

To illustrate this point I will describe a scene I witnessed a few years ago in the garden of the Museum of Modern Art in New York. A man proudly flaunting an elaborate Nikon camera, complete with 400mm lens, was preparing to take a picture. His equipment certainly must have cost at least $600, but what was his subject matter? It was his girlfriend, striking a stiff, uncomfortable pose reminiscent of a department store dummy. Because of the extreme magnification of the lens, which really should have been mounted on a tripod, she had to stand a great distance from him in order to be entirely included in the picture. I departed as he screamed frantically across the crowded garden, "Smile!"

If there is a moral to be found in this little vignette, it might be that it isn't necessary to spend a lot of money on equipment that is inappropriate for your needs. The character described above might have been equally satisfied with pictures taken with a box camera. In short, if your camera is not as exotic as everyone else's, don't worry. I can safely say that I take better pictures with my old $75 Exacta than most of the artsy-craftsy type-photographers wheeling in the heavy artillery.

What I have said about cameras is no less true of darkroom equipment. Part of the problem may indeed be the keep-up-with-the-Joneses mentality, coupled with the mistaken belief that more expensive paraphernalia automatically leads to better pictures. Compounding this problem is the fact that manufacturers of photographic equipment, retail stores, and (alas) photography magazines do their best to perpetuate planned obsolesence, making us feel inferior for not having purchased the latest gadget. As in other areas of consumer buying, there is a decided lack of objective, impartial product tests reported to assist us, the

buyers of these products. One good source of information is *Consumer Reports,* which I urge you to consult before buying a new camera, lens, or enlarger. It is my hope that I will be able to tell you throughout the course of this book when you can safely cut corners in equipment, and how to produce photographs of good quality without taking out a bank loan.

You may have noted that none of the chapters specifically refers to picture taking. It was my feeling that the use of the camera and darkroom skills are so interrelated that they should be discussed within the same chapters. The emphasis of the book, however, remains upon darkroom skills, which are more narrowly technical than picture taking and therefore more appropriate to the manual concept of the book.

Keep in mind that good photography requires patience and an understanding of the medium. It is my hope that you will pick up a few things you may not have known, and, in the process, increase the enjoyment of your newly acquired craft.

For those of you who are technically inclined, all of the photographs in this book were taken with either an Exact VX IIa, a Yashicamat 124, or a Nikon F. I wish to thank my wife Susan for her thoughtful comments and help in preparation of this manuscript.

An Introduction to Black-and-White Film

Black-and-white film processing illustrates basic points about all photographic lab work, and it is a particularly good starting point because a darkroom isn't even necessary. If you are unsure about whether or not to get involved in the intricacies of darkroom work, consider developing your own film as an introduction to the process. In terms of equipment, it is a relatively inexpensive venture and will permit you to select only those negatives you wish to have printed commercially or to print on your own. This new flexibility may in turn result in a modest savings.

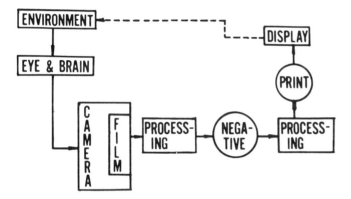

Fig. 1-1. The systematic approach to photography considers every element in the process in relation to every other element. No aspect exists in total isolation.

To the uninitiated, a discussion on the nature of photographic film would probably seem to be a fairly straightforward business, however, any consideration of film must also take into account other photographic elements, such as the camera and the enlarger. This type of approach will help you to understand that photography is systematic; each step is inextricably tied to the preceding and subsequent steps. The picture-making process includes the eye, camera, film, and processing; all are important factors and all are interrelated.

A FEW UNCOMPLICATED WORDS ABOUT FILM

The substance we call film consists of a transparent plastic base coated on one side with a layer of gel. Embedded in the gel are microscopic chemical crystals that are sensitive to light, *i.e.,* their chem-

ical nature is altered when exposed to light. The fully processed film is called a *negative* because the bright parts of the photographed subject are rendered dark, while the dark parts are light or transparent. When the negative is projected onto a photosensitive surface (the photographic paper) and this paper is processed, the light and dark values will reverse, and once again correspond to those we saw when the picture was taken.

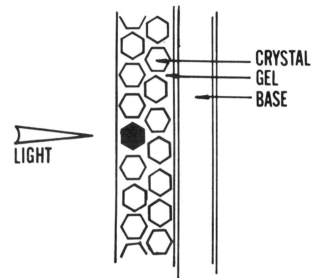

Fig. 1-2. A simplified diagram of film structure. The black hexagon represents a photosensitive crystal altered by light.

THE CAMERA CONSIDERED AS A FILM MACHINE

You may not have thought about it in exactly these terms, but a camera is really only a machine designed to regulate the way light from the environment falls upon a piece of film. The film then becomes a permanent record of a light pattern you wish to preserve. Considered as such a "film machine," the camera must perform three basic functions:

1. It must create an accurate light image upon the film.
2. It must allow you to see the image as it is projected upon the film.
3. It must regulate the amount of light falling upon the film.

The first function of the camera, creating an image, is accomplished by the lens. Rather than permit this friendly chat to degenerate into a complicated lecture on optics, I will say no more for now.

The second function of the camera, permitting you to see what the film "sees, is accomplished with the help of the viewing system, which varies depending upon the type of camera one uses. The viewing system in your camera will fall into one of the following categories:

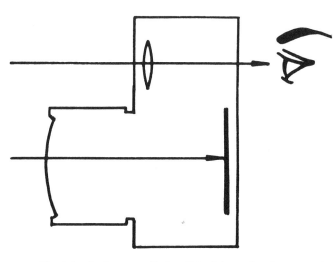

Fig. 1-3. In the rangefinder, light (shown by the arrows) is directed to the eye and to the film by two adjacent but different lens systems.

1. The *viewfinder* system uses two lenses, one for the film, and a second but smaller lens for the eye. The chief shortcoming of the viewfinder camera is that there may be a slight difference between what the eye sees and what the film "sees," because the two lenses are located in slightly different positions.

2. The *twin-lens reflex* camera also uses two lenses: one directs the image onto the film, while the other lens projects the image onto a ground-glass screen where it is viewed. The eye can see a relatively large image, but it still suffers from the inaccuracies inherent in the viewfinder system, *i.e.*, the viewing lens is separate from the taking lens. Also, the image one sees on the groundglass is reversed in the left–right dimension. These cameras are very popular because they project good images to the film and the eye.

3. The *single-lens reflex* system uses a special mirror or prism to direct portions of the same image to both the film and the eye. Left and right

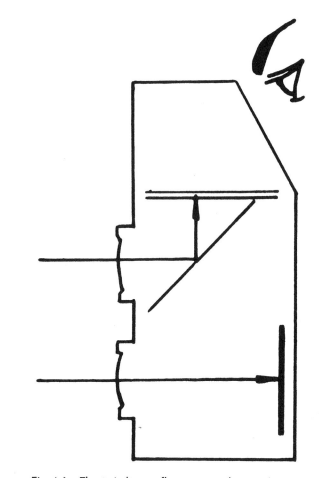

Fig. 1-4. The twin-lens reflex system also employs a two lens system for focusing, but the eye views the image reflected on a ground glass screen.

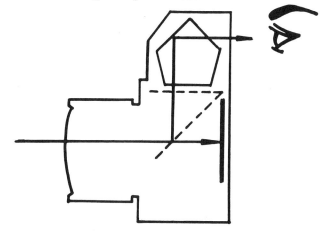

Fig. 1-5. A mirror and prism arrangement in the single-lens reflex camera reflects light from the lens to a ground glass screen visible in the eyepiece. Thus, the photographer can see exactly the same image as is recorded upon the film.

remain normal and the eye sees exactly what the film "sees." Many consider this camera ideal in terms of its viewing system, however, it is frequently more expensive than the previously mentioned cameras.

10

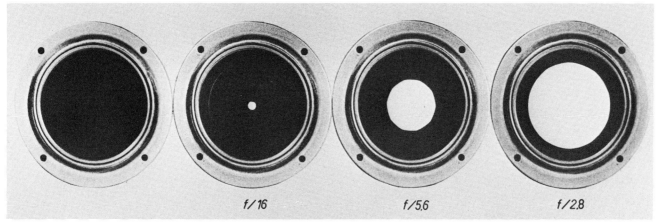

Fig. 1-6. A shutter and aperture device illustrating a closed shutter on the extreme left and open shutters with various apertures in the remaining pictures. Note that as the f/number increases, the diameter of the aperture decreases.

Finally, let's consider the third basic camera function, regulating the amount of light entering the camera. The film, stretched across the back of the camera, can only be altered by a given amount of light. Too little light will fail to change the chemicals deposited on the film (or will underexpose the film), whereas too much light will cause too massive a change (overexposure). Therefore, the camera must have a mechanism by which the amount of light falling on the film can be regulated to assure that the quantity of light is optimal. The regulating process is controlled by two devices within the camera, the *aperture* and the *shutter*. The aperture is merely an adjustable hole through which the light must pass before reaching the film. Obviously the diameter size of this opening will have a lot to do with the amount of light falling upon the film. One of the more confusing aspects of aperture terminology is that the size of the opening is referred to by a system of f/stops rather than by direct reference to the diameter of the hole. The relationship between the magnitude of the f/number and the diameter of the aperture is inverse, *i.e.,* the smaller the f/number, the *larger* the diameter of the aperture. For instance, at f/22 less light enters the camera than at f/8. (The aperture also regulates a second optical property, "depth of field," but we will skip this for now and discuss it in a later chapter.)

The second light regulator, the shutter, may be pictured as a curtain that lets light enter the camera if it is raised. If the shutter is open for one second, more light will strike the film than if it had been opened for only 1/100 sec. Therefore, we have two means at our disposal for determining the amount of light that will fall upon the film: the diameter of the aperture and the operation of the shutter.

Thus, for example, if we find it necessary to increase the amount of light entering the camera, we can either make the shutter stay open for a longer period of time or change to a smaller f/stop (larger aperture, remember?). Of course, if the shutter speed is too slow, we may blur the picture because of our body movements or those of the subject during the exposure. Too large an aperture may also prove detrimental to the clarity of the picture, so we usually have to make a compromise between the extremes of the f/stops and shutter speeds.

FILM SENSITIVITY

With few exceptions, photographic films are highly sensitive to light, but the degree of sensitivity varies with the type of film. A convenient index of this sensitivity is a numerical scale devised by the American Standards Association and, therefore, abbreviated as the *ASA scale* or *index.* As the number of the ASA index increases, so does the sensitivity of the film to light. It follows that more light will be required to expose a film of ASA 125, such as Kodak Plus-X, than will be needed to expose an ASA 400 film like Kodak Tri-X.

All of the following statements can be made about film sensitivity:

1. All other circumstances being equal, one can use a smaller aperture with a "faster" (more sensitive) film than with a "slower" (less sensitive) film, because less light is required to expose the film.

2. All things being equal, one can use a faster shutter speed with a faster film than with a slower film.

3. A faster film can be used more readily in

11

a low-light situation, such as indoors, than can a slower film.

If all that I have said so far is true, why not always use the highest ASA film obtainable? The answer is simply that increasing the sensitivity of the film often results in a corresponding diminution of picture quality. To be more specific, in order to make a more sensitive film, the manufacturer must expand the diameter of the photosensitive crystals, and, by doing so, increase the chance that the particles will be perceptible when the film is developed and printed. This increase in *grain* often shows itself as a fuzziness or lack of contrast in the finished print, particularly if the print is greatly enlarged.

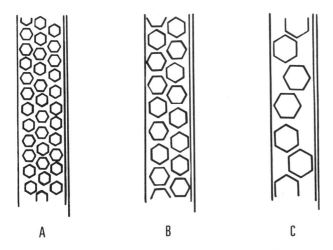

Fig. 1-7. Film speed and graininess: Diagram A depicts a fine-grain, "slow" film; B a moderate-grain, moderate-speed film; and C a large-grain, "fast" film. Film speed is a function of grain size.

Fast films are appropriate for some situations where one knows in advance that environmental light will be at a minimum, but certainly not all circumstances, nor even most. If, for example, your pictures have had a blurred quality not attributable to poor focusing, you might try switching to a slower, smaller grained film, say from an ASA 400 film to one of ASA 125 or even ASA 32.

Before I leave the topic of negative quality, let's consider what might be called an "ideal" negative. As I have already indicated, such a negative would first have to depict sharp detail, largely a function of how carefully the picture was originally focused in the camera as well as the speed of the film used. An equally important property is something called *contrast*. The concept of contrast defies easy definition, but I will try to simplify it. Imagine, if you can, that you

have just taken a picture of an "average" scene. By average I mean a scene that has in it both very bright and very dark values, and all of those values in between, namely the varieties of grey, for instance, a properly illuminated human face. Logically, when this negative is developed, it should have all of the different brightness values—white, black, and gray—reversed from the way they originally appeared in the scene. It is important to obtain this sort of a brightness distribution so that the subsequent print will accurately reproduce the appearance of the scene as it was photographed. But, human nature being what it is, we sometimes make little mistakes and produce a less than ideal negative. Usually such a goof shows itself as either a very pale, underexposed, "thin" negative, or a very dark, overexposed, "thick" negative. In both cases, normal or ideal contrast has suffered, and unless some compensation is made in the printing process, the result will not prove satisfactory. Negative contrast errors may result from improper exposure in the camera or improper development. The only way to consistently obtain negatives of good contrast is to be sure that you properly expose the negative when you take a picture (a good light meter helps here), and, second, to adhere rigidly to uniform processing procedures. For the remainder of these chapters I will assume that you want sharp pictures with good contrast properties and will direct my efforts toward your achieving that goal.

To complete the topic of film sensitivity, I would like to mention a practice one sometimes encounters called *pushing*. Pushing is using a roll of film as if it had a higher ASA value than the one indicated by the manufacturer. In order to process this film correctly by "pushing," you must extend the developing time or use a special developer. For example, Tri-X film, normally rated at ASA 400, can be used at ASA 1200 and then developed with a chemical such as Acufine developer to obtain the higher rating. At first this would seem to be an easy way to make a slow film into a fast one, and in a sense it is. On the other hand, one rarely gets something for nothing. In this case the user often sacrifices a certain amount of clarity because of the increased grain and contrast brought on by the abnormal processing. I feel that pushing should not be an everyday practice, but rather limited to situations where one needs a faster film but simply cannot get one. The ASA value indicated by the manufacturer of the film is always the ideal one to work with. Keep

THIN NORMAL THICK

Fig. 1-8. Negatives (top row) and the prints derived from them may vary in contrast. A "normal" or "average" negative (center) is a product of correct exposure in the camera and proper processing.

in mind that whenever you select a faster film over a slower one, whether by differential ASA ratings or by pushing, you run the risk of decreasing the quality of your work.

BUYING AND STORING FILM

Black-and-white films are distinguishable from one another on the basis of ASA ratings and consequent grain characteristics. As a general rule, remember that the higher the ASA value, the more prominent the grain will be. Fine-grain films usually have ASA numbers below 100, medium-grain films have ASA numbers from 100 to about 200, and course-grain films have ASA numbers above 200. The film speed is always printed on one side of the film box.

When you purchase film, take a few moments to examine the box in order to find the expiration date. This date is just a convenient way to tell you that the emulsion will not last forever, and

will, in fact, deteriorate rather badly after a period of time. Don't worry though, this process takes a few years. Nevertheless, the manufacturer indicates a date after which time he feels the quality of the image produced on the film may be harmed by deterioration; this data is usually somewhat conservative. Although I have only done this in a pinch, I have found that film can be used several months after the expiration date. You will rarely encounter out-of-date film because the turnover rate in most stores is very fast and film is not allowed to accumulate. It still might be a good idea to check the expiration date, particularly if the film is purchased in a store with a low sales volume, or if you use an odd type or size of film.

The greatest enemy of emulsion stability is heat, particularly prolonged storage temperatures above 80° F. If you don't contemplate using a roll of film within a few days of purchase, then store it in the refrigerator. I usually keep a few rolls

13

Fig. 1-9. Long-term film storage is accomplished by sealing the film in a plastic bag and placing it in the refrigerator.

of film of assorted speeds in a tightly closed plastic bag in the rear of the refrigerator. Although this practice evokes some peculiar remarks from ice-box raiders, it is a good way to insure that film will be available when needed.

DEVELOPING FILM IN THEORY

Let's assume that you have shot a roll of film and are ready to process it. The light entering the camera has already changed the chemical nature of the film's *emulsion* (photochemical-on-gel). The developing procedure merely amplifies this minute change and makes it permanent.

The exposed film is first immersed in a chemical *developer,* which transforms the exposed areas into varying degrees of opacity and leaves the regions not touched by light relatively transparent. In order to halt the development, a second chemical, the *stop bath,* replaces the developer. Finally, the film is bathed in *fixer,* which acts to harden the emulsion and make the negative permanent. In theory, at least, that's all there is to it!

Getting started

In this chapter and the next, I will describe the chemicals, equipment, and techniques you will need to process film. You will quickly discover, I hope, that there is no magic in processing, and it may even become routine.

The first problem you will probably encounter will come the moment you set foot in the nearest photo supply store, at which time you will be faced with a confusing, even baffling, assortment of photographic paraphernalia. How do you know what to buy? You really only have two choices:

1. Know exactly what you want before you walk in.
2. Allow the salesman to tell you what you need.

The first choice is preferable because there exists a certain kind of photo store in which the salesman will gladly sell you the display cases if you let him. (Don't get the wrong idea, however, most photo stores are honest and sympathetic to your problems.)

One way to get started is to purchase a film developing kit, such as the beginners' outfits manufactured by GAF, FR Corp., or Paterson. These kits include most of the basic chemicals and supplies needed to process black-and-white film. You will still have to purchase a few odds and ends, which means that you must understand what the contents of the kit are used for in order to buy the items it has omitted. The chief advantage of the kit is that it offers a certain amount of security to the beginner; it may even be a little cheaper than buying the individual supplies, although I have my doubts. The primary drawback of a kit is that its contents are sometimes toy-like and might prove inadequate if and when you become more seriously involved in processing. Before I leave the topic of kits, please note that some kits contain *contact printers* and small trays for crude print processing; in my opinion, these devices are largely useless and a needless expense. So if you want to buy a kit, make sure it is for film processing only.

If you decide to buy individual supplies, it would be advisable to prepare a list of everything you will need and determine which items you already have (like bottles and clothespins) and which items you will have to purchase. A sample list appears at the end of this chapter, indicating most possible items you might need. The precise brands selected are a matter of personal taste and local availability, but I urge you to read the next chapter *before* you blindly follow this list. You may discover that you don't need every item, or that there are inexpensive but adequate versions of some items available to you. I'll have more to say about chemicals in succeeding chapters, but a good rule of thumb is to purchase all of your chemicals from a single manufacturer because they are specifically formulated to work with one another. So, if possible, purchase all Kodak, or Edwal, or FR Corp. chemicals rather than mixing brands. Once you are familiar with their properties, you will be free to experiment and assort chemicals to your heart's content.

Now for that list I promised you:

Chemicals

1. Developer
2. Stop bath
3. Fixer
4. Hypo neutralizer
5. Wetting agent

Equipment

1. Changing bag
2. A pair of children's scissors
3. Bottle opener
4. Hole punch
5. Developing tank
6. Graduated beakers (3)
7. Photographic thermometer
8. Storage bottles (4 or 5)
9. Funnel
10. Clothespins or clips
11. Soft brush
12. Glassine envelopes

2
Film Processing

Developing your first roll of film will probably be the event that hooks you on photography for a lifetime. Just contemplate for a moment that here is something *you* will do, not some nameless factory. The first roll is the most exciting, but a little bit of that excitement lingers on with every succeeding set of negatives you create. In addition to your sense of satisfaction, home processing has several advantages over commercial processing. It is cheaper, and, more important, it gives you a degree of control over the final product that mass production cannot afford.

Before we get into the mechanics of processing, I'd like you to keep a few general rules in mind. I know they sound trite and corny, but they really are important:

1. *Be patient:* Rushing and careless shortcuts often result in either poor negatives or none at all. Even though we are all entitled to a certain number of stupid mistakes, successful processing requires that each step be performed correctly for the next step to succeed.

2. *Prepare everything in advance:* Nothing is quite so dismal as reaching for a chemical that was never mixed or a piece of equipment that was never purchased. Careful preparation will become routine. However, when you begin, check and double check to make sure you haven't forgotten anything.

3. *Be neat:* Neatness is particularly important if your darkroom exists where people engage in other activities. PHOTOCHEMICALS ARE POISONOUS! Store chemicals where children cannot reach them and where they cannot come in contact with food. In addition, keep a damp rag or paper towel around when you are working to wipe up spills.

I think these three rules are the only ones that cannot be modified or broken. Keep in mind that there is more than one way to develop film, although the principle is the same in each system. You may discover variations that are more to your liking after you have acquired the basic skills.

WHERE TO WORK

Work in the kitchen or bathroom next to a sink, because you will need quite a bit of running water and because these areas are the most easily cleaned. As you will shortly discover, a formal darkroom is not necessary for processing film even though the exposed film must not be contaminated by light. Allot yourself one hour per roll of film (a generous figure) so that you will be undisturbed in your work.

CHEMICALS

You will unquestionably need *developer, stop bath,* and *fixer* (also called *hypo*). In addition, you may find it convenient to use a *hypo neutralizer* and a *wetting agent,* which I will discuss as we proceed. Photographic chemicals are most often purchased as liquid or powder concentrates and then mixed with water to obtain mixtures called *stock solutions*. In some cases, particularly with developers, it may be necessary to dilute the stock solution further in order to obtain a *working solution*. Usually, however, a portion of the stock solution is used directly as the working solution, *i.e.,* the liquid with which you actually process.

Developers

There are many different film developers on the market today, with manufacturers adding to the list on a regular basis. Are so many different developers really necessary? Perhaps. Part of the problem is that the developers made by one company often duplicate the properties of those manufactured by another. A more important consideration is the application of the developer; different developers are intended for different purposes, and developers may vary with regard to convenience. Let's consider some of the criteria by which film developers are made, and some examples of each category:

Application: Some companies that manufacture developers intend them to be used only with their own films (for obvious economic reasons). For example, the data supplied with Kodak, Agfa, or GAF developers apply exclusively to the films manufactured by these companies. Kodak does not include information on how to use any of their developers with GAF film, even though it might be possible to do so. Sometimes, even within a

given brand, the developer may be used only with some of the manufacturer's films.

Other brands of developers may be used with several different brands of film. For example, the Acufine, FR, and Ethol brands include data that allow them to be used with more than one brand of film.

Finally, there are developers that may be used with both film and paper development, such as Kodak D-72, Kodak Versatol, Ilford PQ/Universal, and Ilford ID-36. I tend to avoid these because I think their performance is less than ideal in either situation.

Exposure and grain: Some developers are intended specifically for use with pushed film (see Chapter 1), whereas others are meant to be used for normally exposed film. In addition, developers may vary in the degree to which they produce grain; for example, there are developers whose manufacturers claim will produce ultra-fine-grain, fine-grain, or moderate-grain characteristics. If a pushed film is used, of course, the grain will automatically be coarser than if the film had not been pushed. Ultra-fine-grain developers are not always used because they sometimes sacrifice good contrast.

Some developers that can be used with a wide range of normally exposed films include: Edwal FG-7; Ethol TEC; FR X-44, X-22, and X-100; GAF Isodol; and Kodak D-76, HC-110, and DK-50. For fine-grain development of normally exposed film one can use Acufine's Autofine or Diafine, Edwal Super-12, FR X-33C; or Kodak Micro-dol-X.

For pushed film with moderate-grain characteristics try Agfa Rodinal; for fine-grain pushed film use: Acufine's Acufine, ACU-1, or Diafine; Edwal Super 12; Ethol UFG; or GAF Hyfinol.

Form and shelf life: Some developers are packaged as liquids, some as powders. Some may be reused as they are or by adding a chemical *replenisher*, whereas others can be used once and then must be thrown away. In addition, once the developer has been made into a stock solution, it may deteriorate after a period of time, much like film. This property of *shelf life* must also be taken into consideration when buying a developer.

Are you sufficiently confused by now? Well, things aren't really that bad. For your first developer, I suggest you select one from the first group mentioned above because chances are you will be using a normally exposed, standard type film. Once you have mastered processing with your first developer, you will be free to experiment with new films and new developers, which in fact is a practice to be encouraged.

SAMPLE DEVELOPING TIMES (min.)
Temperature of the Developer (°F.)

Developer	65	68	70	72	75	80	Dilution (developer: water)
D–76							
Plus-X Pan							
35mm and Roll film	10	8	7	7	5	—	1:1
Tri-X Pan							
35mm and Roll film	13	11	10	9	8	—	1:1
Microdol-X							
Plus-X							
35mm and Roll film	11	9	8	7	6	—	Full strength
	—	—	13	12	11	—	1:3
Tri-X Pan							
35mm and Roll film	13	11	10	9	8	—	Full strength
	—	—	17	16	15	—	1:3
Autofine							
Plus-X Pan							
35mm	$9\frac{1}{2}$	—	$7\frac{1}{2}$	—	6	$4\frac{3}{4}$	Full strength
Roll film	$6\frac{1}{2}$	—	5	—	4	$3\frac{1}{4}$	Full strength
Tri-X Pan							
35mm and Roll film	11	—	$8\frac{3}{4}$	—	7	$5\frac{3}{4}$	Full strength

Stop baths and fixers

There is considerably less to worry about when you buy a stop bath and fixer. Stop baths are always named as such, and fixers always have the syllable "fix" or "hypo" in their brand name. These chemicals vary very little from brand to brand except that some may act faster than others. Note that fast-acting chemicals are often designated *rapid,* for example, there is a Kodak Fixer and a Kodak Rapid Fixer; these vary with regard to their speed of operation.

PREPARING CHEMICALS

I find it best to mix all of the stock solutions beforehand, which makes enough chemicals for several rolls of film. Because all photographic chemicals may deteriorate after a period of time, it's a good idea to mix them in relatively small quantities (a gallon of each at most) to be assured that the chemicals are always fresh. Although storage bottles specifically made for this purpose are available, I think they are a needless expense; thoroughly washed glass or plastic containers, such as used bleach bottles, serve the purpose just as well. Instructions for mixing are enclosed with the concentrates or are printed on the label. If the bottles have narrow mouths, a kitchen funnel may be used to avoid a mess, and a long metal or glass rod will help to dissolve powdered chemicals in the water. Inexpensive glass rods can be purchased where bar supplies are sold.

Mark the contents of each bottle directly on the container with a felt-tipped marker or crayon.

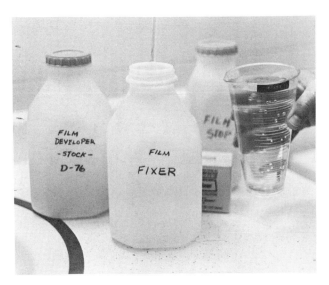

Fig. 2-1. Preparing chemical solutions.

You'll have to do some measuring when preparing chemicals; most photo stores sell cheap plastic graduated beakers for this purpose. Glass ones are more expensive and more breakable. Be certain that the beakers you select have at least a 16-ounce capacity. When you store stock solutions, keep them separated from the rest of your supplies, in case one should accidentally leak or spill.

EQUIPMENT

The exposed film taken directly from the camera is contained in a lighttight container, either a metal cassette or several layers of tightly wound paper. This is a very real precaution against accidental exposure of the film to stray light that could easily mar or even destroy the latent image. In fact, it is crucial that the film remain in a totally light-free environment for the duration of the development procedure. Even a specially prepared darkroom may be subject to light "leaks" through cracks in windows, doors, or ventilating ducts; and using such a facility may run the risk of contaminating the film with visually undetected stray light. For this reason, I strongly recommend the use of a developing tank and a changing bag.

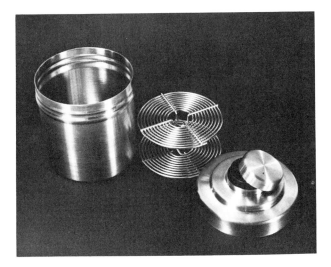

Fig. 2-2a. A stainless steel tank capable of holding two 35mm reels (center), and its cover and cap.

The *developing tank* is a lighttight container that holds one or more reels onto which the film is threaded in total darkness. The sealed tank may then be removed to a normally illuminated room for chemical development. Tanks are manufactured in a wide variety, ranging from inexpensive black plastic ones to more costly stainless steel ones. The plastic tanks are relatively cheap and may be

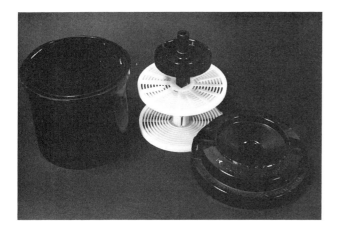

Fig. 2-2b. A black plastic tank showing outer container, reel, and cover.

adjusted to accept different film sizes. Steel tanks are more expensive, but are virtually indestructible and may be used to process several rolls of film simultaneously. Tanks also vary in the way film is loaded into them. Since both types of tank will do the task, it makes sense to buy the cheaper one, particularly if you don't wish to make too large an initial investment.

In general, the tank consists of three parts: an outer container, a reel onto which the film is threaded, and a lighttight top having an opening through which the chemicals are poured. Metal tanks have a cap to seal this opening.

Load the film into the tank inside a *changing bag, i.e.,* a cloth and rubber sack consisting of a double zippered bag with two arm holes held tightly to the arms by elastic bands. The changing bag is a darkroom in miniature, removing the necessity for a formal facility.

If using 35mm film, you will also need a pair of *scissors* inside the changing bag to cut the end

of the film square. Small, inexpensive children's scissors are recommended because they cannot cut the bag (or your hands). The 35mm metal cassettes are opened with a common *bottle opener,* which must also be taken into the bag. In addition, a *hole punch* may be needed in order to prepare the film for attachment to the reel, but this depends upon the construction of your tank.

For chemical processing you will need three *beakers.* You will also need a *photographic thermometer* which may vary in price from reasonable to extravagant. The cheap ones are pretty accurate, but they take longer to reach the desired temperature. A *watch* with a sweep second hand is used to time the development period; although a stop watch is ideal, a kitchen timer may be substituted.

The last pieces of equipment are for finishing the negatives. These include a photographic *sponge* or *sponge tongs* (available at the photo store) and *clips* from which the wet film is hung up to dry. The best clips are spring-type clothespins or spring paper clamps available at the stationery store for 10 or 15 cents. The dried film is stored in *glassine envelopes,* also available from the photo supply store.

Fig. 2-4. Load the changing bag, close it tightly, and then insert your arms.

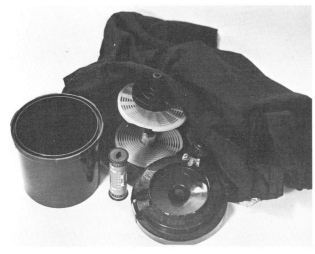

Fig. 2-3. Assemble loading equipment.

19

I. LOADING THE TANK

STEP 1: *Assemble all of the loading equipment,* including changing bag, disassembled tank, bottle opener, scissors, and hole punch.

STEP 2: *Place all of the equipment and the film into the innermost sack of the changing bag.* Close both sacks tightly, reduce the room illumination to dim, and insert your arms. Don't wear a wristwatch with a luminous dial for obvious reasons. The remaining steps are performed inside the changing bag:

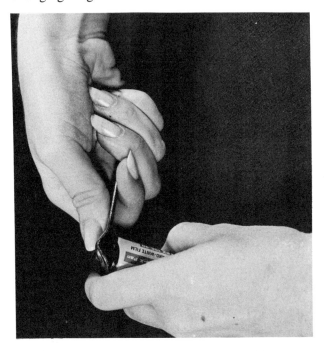

Fig. 2-5a. Pry off the flat end of the 35mm film cassette with the bottle opener.

Fig. 2-5b. Push the film spool free of the cassette.

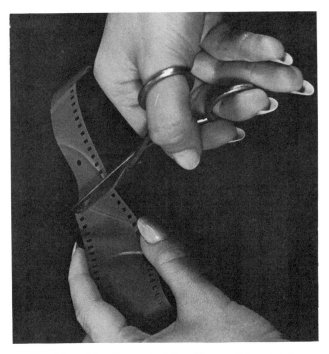

Fig. 2-5c. Trim the end of the film so it is square.

STEP 3: *Extract the film from its container. 35mm film:* Using the bottle opener, pry off the flat end of the cassette, and push the film out by the protruding spool on the other end. *Paper-wound film* (Sizes 120 and 220): Break the seal around the outside of the spool. Unwind the paper, forming a coil as you proceed; a second coil, the film, will soon form. Continue unwinding until the entire length of film has coiled, and set aside the paper and spool.

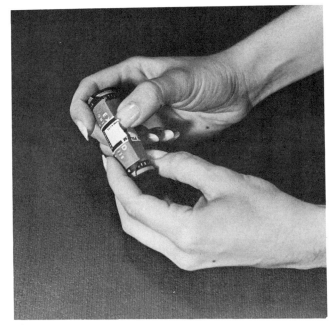

Fig. 2-6a. With paper-wound rolls, first break the seal.

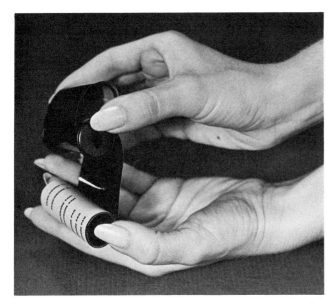

Fig. 2-6b. Unwind the roll, forming two coils (paper and film) until the spool is reached.

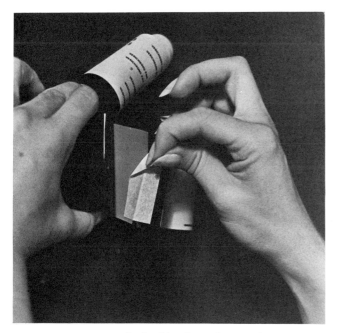

Fig. 2-6c. Detach the film from the spool.

STEP 4: *Trim film end* (35mm *only*): Using the scissors, clip the end of the film just beyond the slanted end so that you square it. This makes subsequent steps easier.

STEP 5: *Secure the film end to the reel.*

Center-loading reel: Holding the film by the edges, press slightly so that the film buckles, which makes it easier to get to the center of the reel. The end of the film is secured to the reel by catching it in a spring clip or by impaling it on a metal hook. If you use the hook catch,

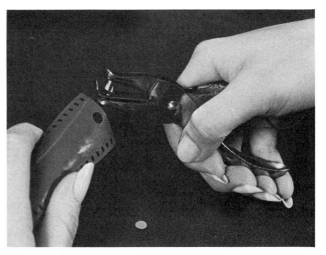

Fig. 2-7a. If the tank is of the center-loading type with a metal hook catch, make a hole in the leading edge of the film with the hole punch.

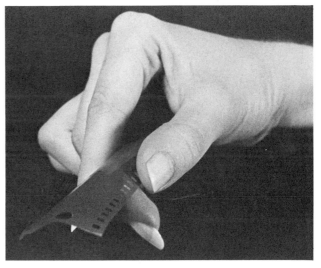

Fig. 2-7b. Holding the film by the edges, buckle it slightly.

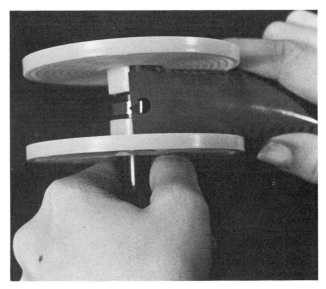

Fig. 2-7c. Attach the film to the center of the reel.

you can save wear and tear on your flesh by first punching a hole in the end of the film with the hole punch and then slipping the film over the hook.

Edge-loading reel: (such as the GAF tank): Slip the film under the protruding sections of the rim of the reel until it "catches."

STEP 6: *Wind the film onto the reel.*

Center-loading reel: Continue buckling the film slightly with one hand as you rotate the reel with the other hand. Check every so often with your finger tips to be sure that the film is going into the grooves smoothly and is not

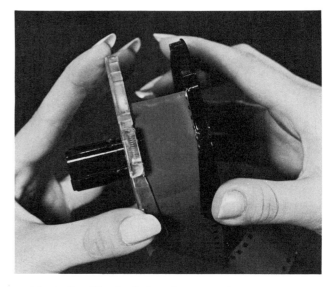

Fig. 2-8b. Edge-loaded tank: Twist the two halves of the reel alternately.

bending or folding. Continue until all of the film has been taken into the concentric grooves of the reel.

Edge-loading reel: Using both hands, twist the two sides of the reel back and forth alternately; the film will be wound automatically onto the reel. You will know when all of it has been taken up because the reel will be much easier to twist.

STEP 7: *Close the tank.* Place the reel in the tank and screw on the cover. (If the reel is the type with a stem that protrudes to the outside of the tank, give the stem a few test spins to make certain that no scrap film has wedged between the reel and the container.)

STEP 8: *Remove the tank from the changing bag.* With the top of the tank securely in place, room light cannot affect the film. From now on the processing occurs in the tank while you remain in normal illumination.

If, during the loading procedure, you encounter any problem, remove the film from the reel, and start all over again.

Keep in mind that a wet tank is much more difficult to load than a dry one. Therefore, thoroughly dry your tank after each use. Edge-loading tanks are particularly difficult to load when the least bit damp.

It is very important that you practice loading the tank before you actually tackle a roll of exposed film. Using a roll of unexposed film, go through all of the steps outlined above as though it were the real thing. Repeat the procedure several times looking at what you do, then try it a few

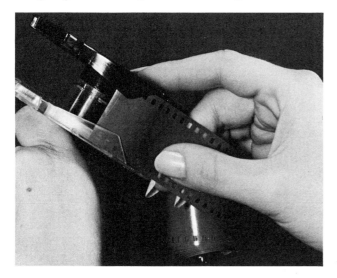

Fig. 2-7d. With an edge-loaded tank, simply slip the film under the edges of the reel.

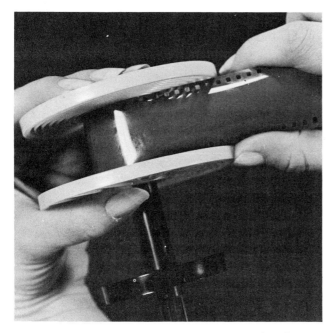

Fig. 2-8a. Center-loaded tank: Turn the reel with one hand while keeping the film buckled with the other.

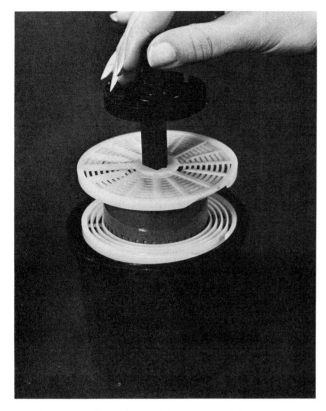

Fig. 2-9a. Place the reel into its container.

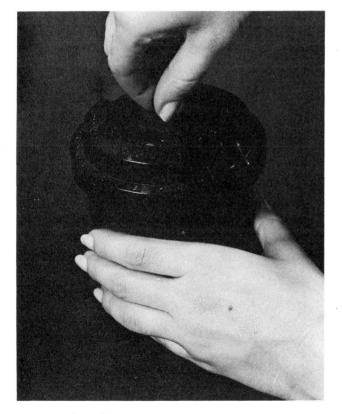

Fig. 2-9b. Close the cover securely, and test spin the reel if the tank permits.

times without looking at your hands, as would be the case in the changing bag. Even though the practice film will cost you a few cents, it is money well spent because it will save you aggravation later on when valuable film is at stake.

Fig. 2-10. Assemble chemicals and measure processing fluids.

II. CHEMICAL PROCESSING

STEP 1: *Assemble chemicals.* Work near a sink, and prepare three beakers with working solutions of developer, stop bath, and fixer. The precise amount of each solution you mix depends upon the capacity of your tank; the capacity is either indicated on the tank instructions or you can measure the capacity of the tank beforehand.

STEP 2: *Determine developing time.*

a. Consult the instructions for the developer or the information sheet packed with the film. These will indicate a number of time–temperature combinations for the type of film and developer you are using.

b. Measure the temperature of the developer with your photographic thermometer. Let the thermometer sit in the developer for at least five minutes.

c. By referring to the information chart you can now determine that at a given temperature the film should remain in the developer for a specified period of time, Normally an "ideal" temperature is shown in bold print, *i.e.,* a temperature that will produce the best grain and contrast characteristics.

d. In order to obtain the ideal temperature, it may be necessary to warm or cool the solu- 23

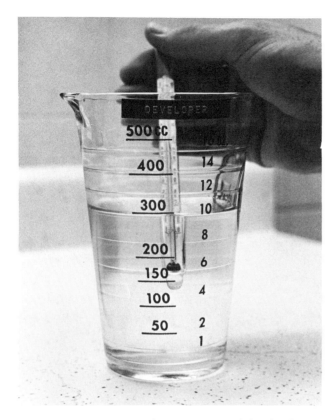

Fig. 2-11a. Determine the temperature of the developer.

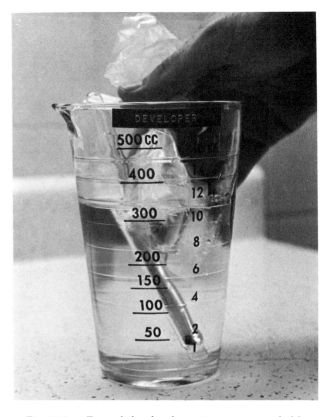

Fig. 2-11c. To cool the developer, immerse a sealed bag of ice cubes into the liquid. Monitor temperature carefully.

tion. To warm the developer, place the entire beaker in a sink full of warm water, but be careful not to let any water slosh into the developer. To cool a solution, place a few ice cubes in a plastic bag, seal the top with a twist closure, and place the whole package into the developer until the desired temperature is reached. This method prevents the ice from diluting the developer.

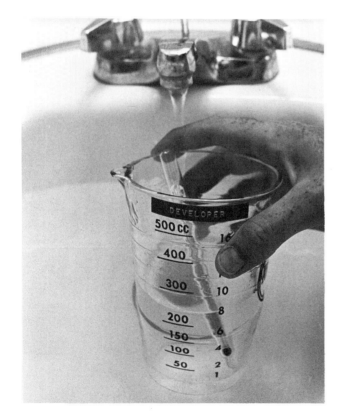

Fig. 2-11b. To warm the developer, partially immerse the beaker in warm water.

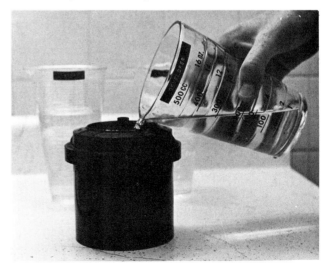

Fig. 2-12a. Pour the developer into the tank.

STEP 3: Pour the beaker of *developer* into the tank.

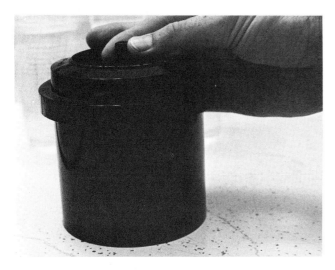

Fig. 2-12b. Agitate the tank at 30-second intervals for the duration of the developing time; agitation, in this case, is performed by gently turning the stem attached to the reel.

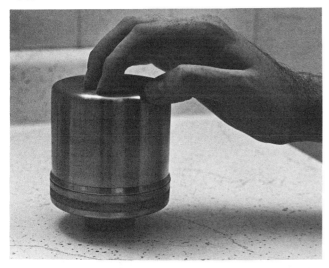

Fig. 2-12c. Tanks without stems, such as stainless steel tanks, are agitated by inverting the tank and tapping it gently at 30-second intervals.

STEP 4: *Agitate* the tank at 30-second intervals. If the tank is the kind with an exposed stem, simply turn this stem gently for a 5-second interval, once every 30 seconds. You may invert the tightly capped stainless steel tank every 30 seconds for agitation. Agitation helps to remove tiny gas bubbles from the surface of the film, and assures even development. Too much agitation is as bad as too little.

STEP 5: *Pour out the developer*—back into the beaker if it is reusable, or down the drain if it is not.

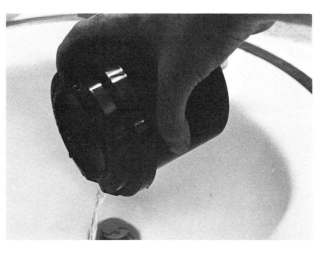

Fig 2-13. Pour out the developer, and save it if it is to be reused.

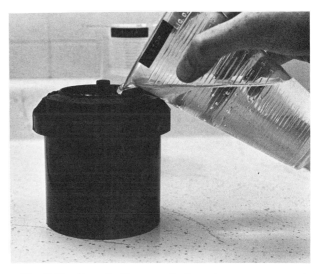

Fig. 2-14. Pour in the stop bath, agitate at 15-second intervals for about one minute, then pour it out.

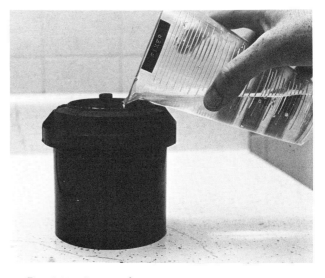

Fig. 2-15. Pour in fixer, agitate at 30-second intervals for approximately five minutes, then pour out.

STEP 6: Immediately *pour the stop bath into the tank* and agitate at 15-second intervals for about one minute. Consult the stop bath instructions to determine the precise stop-bath period.

STEP 7: *Pour out the stop bath.* This chemical is generally *not* reused.

STEP 8: *Pour the fixer into the tank.* Agitate at 30-second intervals for 5 to 10 minutes. Again, consult the package to determine precise times because the ones indicated here are approximate.

STEP 9: *Pour out the fixer,* which is also not ordinarily reused.

STEP 10: *Place the uncapped tank under running water.*

III. WASHING

The film has now been developed, but it has retained a certain amount of fixer (hypo) that must be removed before the film can be dried and stored. Even incredibly small amounts of hypo may cause the film to discolor after a period of time, so this step is vital if you wish to obtain truly permanent images.

One way to remove hypo is to wash the film in running water for at least one-half hour, but preferably for one full hour. A simple way to do this is to remove the top of the tank (light won't hurt the film after it has been fixed), leave the film on the reel, and place the opened container under a running water tap. Because this method requires quite a bit of water (and patience), you may want to hasten the process by employing a *hypo clearing agent,* or *neutralizer.* These chemicals are marketed under a variety of brand names

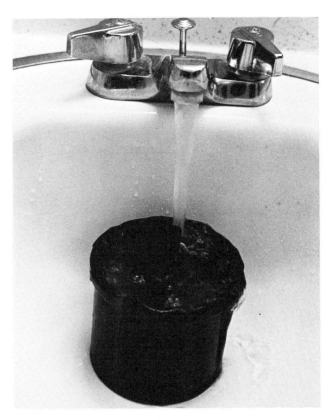

Fig. 2-16b. Wash the film by placing the open container beneath a running tap—for at least one-half hour if no neutralizer was used.

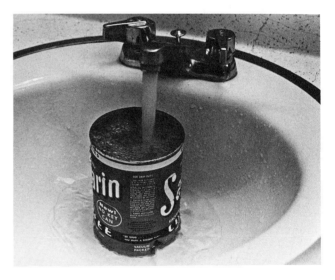

Fig. 2-16c. Another good method for washing film is to insert the reels into a coffee can into the bottom of which holes have been punched.

by virtually all manufacturers, and all will reduce washing time by chemically neutralizing any excess fixer left on the film. Another effective method of washing film is to place the reels in a coffee can that has holes punched in the bottom. The only

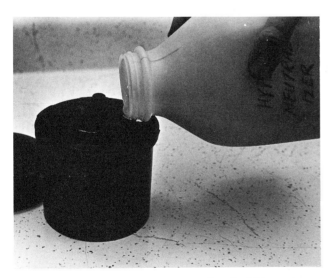

Fig. 2-16a. Immerse the processed reel of film in hypo-neutralizing agent for approximately 30 seconds.

drawback to this method is that you must check for rust in the can, which can ruin the film.

Follow the directions on the container to obtain a working solution for the neutralizer, and immerse the film in this for the indicated time. Pour off the neutralizing solution (which is reusable) and wash the film in running water, but for considerably less time than if water alone had been used, often ten minutes or less.

IV. DRYING

Well-processed films are sometimes defaced in the drying procedure, but this hazard can be reduced by following a few simple steps. A constant source of annoyance is small spots or streaks that appear on the dried film because of evaporated water droplets left on the film during drying. The spots will appear on the print unless eliminated. To avoid the problem, immerse the fully-washed film into a working solution of *wetting agent,* such as

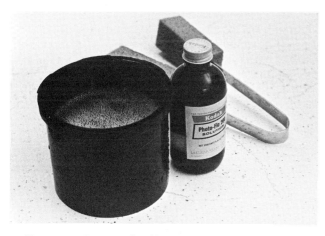
Fig. 2-17. Remove the film from the reel and immerse it in wetting agent.

Kodak's Photo-Flo 200 solution, for about 30 seconds. The solution breaks down the surface tension of water on the film thus preventing the formation of the water droplets. A small, inexpensive bottle will go a long way and is well worth the price (less than one dollar). If we consider the use of a wetting agent to be STEP 1, then the remaining steps are:

STEP 2: *Sponging.* Remove any excess fluid (water or wetting agent) left on the film by gently running a water-softened sponge over both sides of the film. This is best done by holding the film vertically at one end and making a single continuous pass over the film; the sponge should be folded in half over the film so that both sides are swabbed simultaneously. It is important not to

Fig. 2-18. Sponge excess moisture from the film.

press too hard when sponging because it is possible to pick off tiny flakes of the emulsion, which will appear as small black spots or streaks when the negative is printed. A handy gadget, but entirely optional, is sponge tongs consisting of two sponges on spring tongs that simultaneously wipe both sides of the film. Don't buy one unless you find it difficult to work with the single sponge.

STEP 3: *Drying.* The film is dried by attaching a weighted clip to both ends of the film and suspending it by one of the clips from an outcropping, such as a shelf, overhead wire, or shower rod.

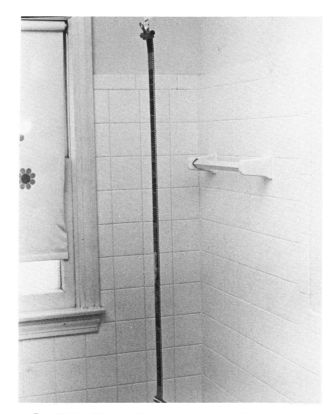
Fig. 2-19. Attach clips to both ends of the film and hang it up to dry.

The clip at the hanging end will keep the film from curling as it dries.

Commercially produced clips are relatively expensive and may even damage the film because some have metal teeth that buckle the film. Instead, use two clothespins or spring paper clamps. Let the film dry for at least one-half hour.

V. STORING

STEP 1: *Remove dust*. Remove any dust particles that may have fallen on the film during drying by gently brushing the surface of the film with a soft camel's hair brush, or by using a *blow brush* (a handy gadget consisting of a brush head mounted on a rubber ball which, when squeezed, produces a puff of air). It is best to brush the emulsion (dull) side of the film as little as possible to avoid scratching the negative.

STEP 2: *Cutting*. The dried film should now be placed on a clean flat surface and cut into smaller strips. It's not a good idea to store film in a coil, because this can scratch the emulsion. The 35mm film should be cut into segments of six frames each, which will permit compact storage yet let you easily handle the film when it is placed into an enlarger. Larger film sizes should be cut into three- or four-frame sections. I recommend that you dust the film again after it has been cut. ALWAYS HANDLE FILM BY THE EDGES! A smudge on the negative will print!

STEP 3: *Storage*. Gently slide each segment into separate glassine envelopes. Never store negatives sandwich style in a single envelope as is sometimes done commercially; you'll want to see

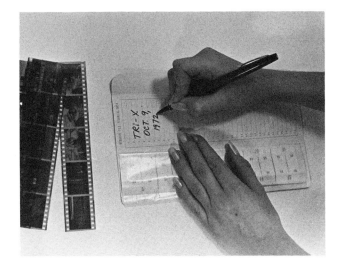

Fig. 2-21. Cut the film into segments and place into individual glassine envelopes.

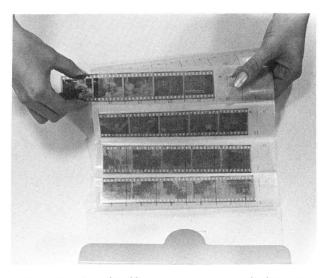

Fig. 2-22. Mark each envelope.

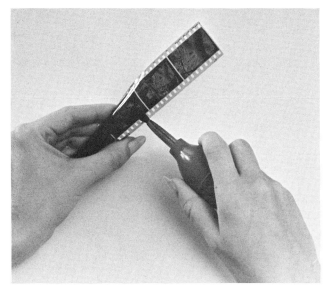

28 Fig. 2-20. Brush off dust particles from the negatives.

each one separately when printing time arrives. Photo stores often sell special negative folders for a dime apiece; these consist of a number of glassine envelopes attached to one another in accordian fashion. They are particularly handy if you think you will be accumulating many negatives.

STEP 4: *Record data*. On the outside of the negative package record any pertinent data that will help you to locate a picture in the future, such as the subject matter of the pictures, date taken, and technical remarks like film speed and exposure values. A simple consecutive numbering system will also assist you in finding specific negatives. Store the negative package in a cool, dry place.

The Bathroom as Darkroom

I'm sure that you're quite anxious to learn all about printing now that you have mastered film processing. It would be appropriate, however, to pause for a moment to consider the physical setting in which photographic prints are created. The situation is not as simple as manipulating a light-tight changing bag and tank as you did with film.

Your problems are accented because space will be at a premium, and because it is likely that your "darkroom" will be a kitchen or bathroom as well. Therefore my main concerns will be with the efficient use of existing space, and creating a multi-purpose work area.

HOW TO MAKE A ROOM DARK

If I were making rules, my first rule might be: A darkroom doesn't have to be as dark as you thought it had to be. In short, now that you have developed the film, you can tolerate a slight amount of light in the darkroom, a concept that my photographic colleagues may find heretical. You see, photographic paper is not nearly as sensitive to light as is film, which means that a small amount of light won't affect it. This is fortunate for many reasons, one being that we need not become fanatical about total darkness in the work area.

A prime consideration in selecting a work space should be the number of windows and doors present in the room. Simple windows and flush doors are easy to make lightproof. Room openings without doors are much more difficult to deal with as are odd types of windows, particularly skylights. For this reason, first consideration for your darkroom should be given to an area that is already largely enclosed.

How to opaque windows

Perhaps the simplest way to eliminate light from windows is to tack a piece of cloth (felt is very good for this purpose although a heavy towel will sometimes work) around the frame of the window Pushpins with heavy heads are recommended because they can be quickly secured and quickly removed. This technique is good because it does not alter the window itself, leaving the room quite normal looking when it is not being used for print-

Fig. 3-1. Sometimes a rag or towel tacked over the window is sufficient to obscure light.

ing. The disadvantages are that unsightly pinholes accumulate in the window frame, and light leaks are still possible where the cloth meets the frame. Some people may also find it annoying to have to go through a pinning ritual every time they feel like printing.

A more permanent sort of solution is to tape felt or cardboard to the window, either in one or two large pieces, or in smaller sections to match single panes of glass. The best tape to use, by the way, is vinyl electrical tape because it won't permit light to pass through as will some other kinds, *e.g.*, white adhesive tape. Because one could hardly go through this process every time he printed, the cardboard and tape technique should be considered fairly permanent. This method is particularly well 29

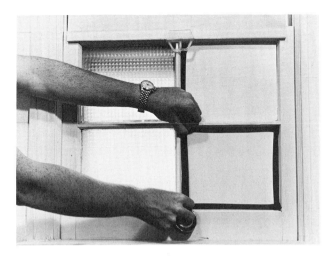

Fig. 3-2. Better lightproofing is assured by fixing cardboard to the windows with stretch vinyl electrical tape.

suited to apartments, where more drastic alterations are out of the question. The obvious disadvantage is that the room will be void of sunlight *all* the time. In addition, cardboard may buckle with time in the humid conditions of a bathroom or kitchen and may have to be replaced. A similar method uses stick-on vinyl, *e.g.,* Contact paper, in place of the cardboard. This substance is water repellent and eliminates the need for tape, but heat and light may make the adhesive tacky and difficult to remove. As you might expect, the darker colors are less transparent than the lighter ones, but it may still be necessary to use more than one layer in order to fully opaque a window. Additional tape may be needed where one window section meets another, or where one frame abuts another frame.

The most permanent alteration is to nail or screw 1/4-inch plywood panels over the entire window. To insure a good seal between plywood and frame, glue a one-inch strip of felt along the edges of the panel. Frankly, I don't care for this treatment because it is drastic and unattractive, but if the room is not to be used for anything else, you may wish to try it. A less radical way to obscure windows is to paint the glass with a dark enamel; inaccessible windows, like skylights, should be painted. This scheme, like some of those mentioned above, tends to transform the room into a permanent darkroom rather than having a bathroom or kitchen serve as a darkroom from time-to-time.

Sealing light leaks in doors

Doors only have to be sealed along the edges where they meet the door frame. In many cases light

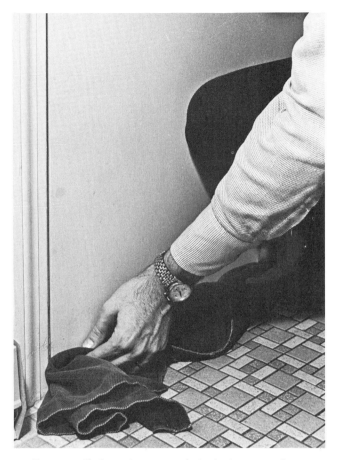

Fig. 3-3. If the only serious light leak past a door occurs at the bottom, stuff a towel in the crack.

only passes through the crack along the bottom of the door. One way to remedy the problem is so stupid I almost hesitate to mention it, namely, stuff a towel or large rag into the crack. I like this because the door remains unaltered when the room must be used again for its original purpose.

For those who find the towel-in-the-crack technique haphazard, the door may be fitted with felt weather stripping, which is available at most hardware stores. To apply weather stripping simply glue or staple strips of the felt to the door so that it meets the floor or overlaps the door and frame. Weather stripping is unattractive but effective, and is usually the best solution to the problem of light leaks between the door and vertical parts of the frame. Weather stripping is also manufactured in a reinforced form, which is less likely to buckle with the passage of time, and, incidently, is more expensive than the unreinforced type.

If you can't cope with any of the suggestions mentioned above then simply hang a blanket over the closed door using pushpins or tacks. The obvious disadvantage of this method is that passage in and out of the room is disrupted.

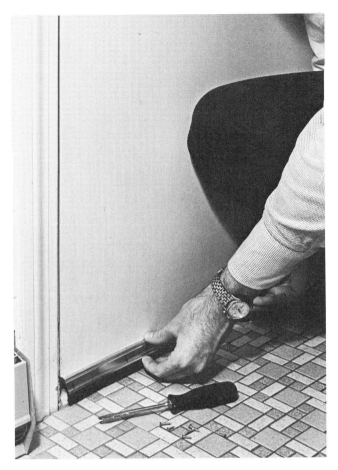

Fig. 3-4. Weather stripping will permanently lightproof a door. Here a piece of reinforced felt stripping is about to be applied to the bottom of a door.

A serious problem with all of these systems is that light blockage is accomplished at the expense of a fresh air supply. There is no simple solution to the ventilation problem. Formal darkrooms usually have a special air circulation system, but for our purposes this is too complicated and too expensive. Actually, I don't find breathing to be as much of a problem as you might suppose. To our good fortune, nature had endowed us with a mechanism for detecting impure air—gasping. Usually, however, the situation does not call for such a dramatic reaction. Remember that the room only has to be dark when unexposed paper is brought out from its protective package; at other times you can safely leave the door ajar, permitting fresh air to circulate throughout the room. As a simple rule-of-thumb: Remember, you can open the door whenever it is possible to turn on the room lights. If the room has a forced air ventilation system or an air conditioner then your ventilation problems are solved. Even a portable fan will help to freshen the air.

Perhaps your light elimination problem is not amenable to any of the schemes described so far, or at least does not appear to be. In this case I would recommend that you use your imagination, keeping in mind the principles described above. It's possible that an apparently hopeless situation may be cured by sealing off as many sources of light leaks as possible and then working at night. Even at night there will be some light present, *e.g.,* moonlight, street lights, and so forth, but the reduction in illumination may be sufficient to make printing possible. Of course you won't be able to work in the daytime, but that may be no more than a minor inconvenience.

IS THE ROOM REALLY DARK?

It sometimes happens that one carefully masks light leaks only to discover, after working for some time, that light has crept in through cracks and crevices that were not previously evident. The reason for this phenomenon is something called *dark adaptation,* which means that over a period of time the eyes are better able to detect light in a darkened environment. Dark adaptation is attributed to a change in dominance from one kind of receptor cell within the eye to a second type of cell, a transformation that normally takes about 30 or 40 minutes to accomplish. For this reason it is possible for one to detect light that he did not previously see in a darkened room, but only after a period of time. This formerly undetected light may be sufficient to expose sensitive photographic materials.

It happens that the dark-adapted eye is such a good light detector that no instrument has been invented to improve upon it. So when you ask how to determine the effectiveness of your efforts, the means are readity at your disposal: simply sit in the lightproof room for about 30 minutes and look for light leaks. It's a boring pastime I admit, but very effective. Once you have satisfied yourself that the room is relatively light free, chances are that it will remain that way on future occasions, provided you have followed the same precautions each time.

Even if the room permits a tiny amount of light to enter, you need not be alarmed. The crucial question is whether this light is capable of exposing photographic paper during the period of time the paper is neither shielded nor processed completely. Again, a simple test may be conducted. In the darkened room take a small piece of printing paper and, without exposing it, immediately put it through chemical processing just as if it had **31**

been exposed in the enlarger. Then take a second piece of the paper and allow it to sit on a counter in the darkened room for a period of about two minutes, then process it exactly as the first piece. The two minute period is about the same amount of time a piece of paper would have to withstand stray light if you were actually printing. When both pieces have been processed, simply compare them. If the second piece looks darkened or fogged in comparison to the first, then you know that your precautions were inadequate. This technique is also useful for determining whether your safe-light is effective (see Chapters 4 and 5).

EFFICIENT STORAGE

As your interest in photography increases, so will the number of gadgets and chemical solutions you accumulate. For apartment dwellers the problem can become particularly acute, although the clutter can be kept under control. One way to limit the problem is to avoid buying anything you don't absolutely need, however, this is easier said than done. The solution must be organizing existing space more effectively.

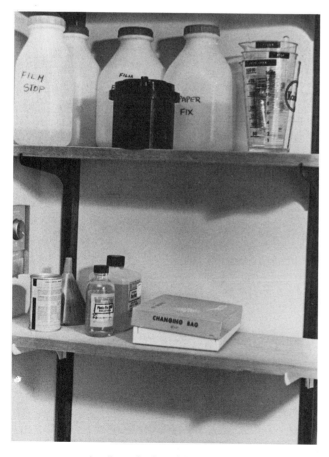

Fig. 3-5. The "standard and bracket" shelving system, now widely available, is both reasonably priced and very flexible.

Getting the most from closets

Most closets consist of a bar for hanging clothes, and a shelf immediately above the clothes rod. I have found that there is often a great deal of wasted space on this shelf, because only a single shelf has been provided.

The logical conclusion, therefore, is to add more shelves. A number of shelving systems are widely available, although I am fond of the type that uses adjustable brackets and slotted standards screwed into the wall. I prefer this system because it is both cheap and flexible. Here are a few hints that may aid you in installing this type of shelving:

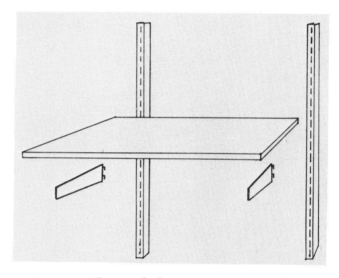

Fig. 3-6. The standards are screwed into the wall, brackets are snapped in, and a shelf is laid across the brackets.

1. Make the distance between wall supports slightly less than the length of the shelf. For example, if the shelves are 36 inches long, separate the standards by about 32 inches.

Fig. 3-7. A simple shelf expander made from scrap lumber consists of three boards fastened together with nails or screws.

2. Supports should occur at intervals of approximately three feet. (A six foot shelf would, therefore, have three supports.)

3. A spirit level will help you to confirm that a standard is vertical.

4. Most modern dwellings have hollow, plasterboard walls that require use of plastic anchors or toggle bolts to fasten the standard to the wall.

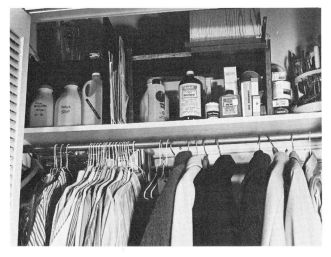

Fig. 3-8. Smaller items and chemicals should be stored at the top of a closet. Notice how shelf "expanders" were used to increase the storage space.

An even simpler closet expander can be made in a few minutes from scrap lumber. An H-shaped addition will often double existing shelf space. It is constructed of three pieces of board—two end pieces and a shelf—nailed or screwed together as shown in the accompanying illustration. The exact dimensions will depend upon the size of your closet.

Fig. 3-9. Save the shipping cartons of bulky items so that they can be placed on the floor of the closet.

A second neglected storage space in closets may be found below hanging clothing; most garments are rarely long enough to touch the floor. Again, shelving or a simple cabinet may be used, or, as I do, retain the shipping cartons of large pieces of equipment, such as the print dryer or enlarger, and store them as inconspicuously as possible at the bottom of the closet. It's best to put bulky items at the bottom of the closet where they are more accessible, and smaller items on top. Chemicals, it should be emphasized, are best stored on the top shelf of the closet where they won't tempt children.

Any closets used for storage will probably serve a number of functions simultaneously, but try to group your photographic gear in one or two central locations.

Fig. 3-10. The steel shelving pictured here is six feet high, four feet wide, and one foot deep, yet it cost less than ten dollars at a local discount store.

Shelves and cabinets

Depending upon the degree of elbow room you already have, you may find even well-used closet space inadequate. In that event, it will be necessary to install some additional shelves or cabinets to accommodate your photographic equipment. When space is limited, it is advisable to build storage 33

space vertically along the walls rather than to occupy more floor space. Again, I state my bias in favor of standard and bracket shelving because of its low cost and flexibility.

I have also found steel storage shelving, which is assembled much like a giant erector set, to be a very inexpensive storage system. A coat of paint will create a remarkable transformation of the normally utilitarian appearance of steel shelving.

Fig. 3-11. Think twice before investing in cabinets. Even these originally unpainted units cost more than metal or wood shelving.

All shelving leaves the items stored exposed to view, which may not appeal to everyone's aesthetic sensibilities. If the exposed equipment really annoys you, then you will have to purchase closed cabinets, which is a drastic escalation in cost but sometimes necessary. Once you have reached this stage, the sky is the limit; costs range from unfinished cabinets you paint or stain yourself to imported rosewood systems. I mention this only for the sake of completeness. Under most circumstances our motto remains, "Think Cheap."

DARKROOM LAYOUT

Now that you have selected a place to work, you will have to consider what to put into the darkroom and how to arrange these elements. Everyone's work area is unique to some extent, and you will have to adapt the principles of darkroom layout to your own circumstances.

The components of your darkroom

For now I'll just list what you will need without going into great detail; further explanations are given in succeeding chapters:

1. *Enlarger* (optional at first)
2. Three plastic *print trays,* at least 8" × 10"
3. Two sets of bamboo *print tongs*
4. Photographic enlarging *paper*
5. A sheet of window *glass,* at least 9" × 12"
6. A photographic *safelight*
7. A *watch* with sweep second hand, or a timer
8. An adjustable *printing easel,* movable to 8" × 10"
9. A soft brush or *blowbrush*
10. *Chemicals:* Paper developer, stop bath, and fixer.

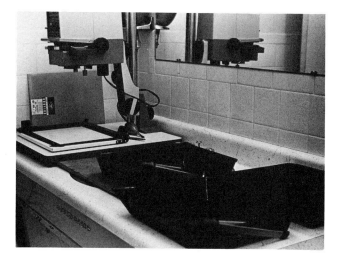

Fig. 3-12. An elementary darkroom layout in the bathroom.

The physical arrangement of darkroom elements

A simple guide in setting up your darkroom is to always establish a *wet side,* and a *dry side* (which I must quickly point out is not a terribly original idea on my part). The wet side of the darkroom consists of the three trays of chemicals, the tongs, and the sink or tub. Although it is desirable to have a source of running water, it is not essential; in most cases an extra tray or bucket of water is sufficient until the prints can be transferred to a sink. The dry side of the darkroom contains the enlarger, enlarging accessories, and the photographic paper.

Unlike film, photographic paper is not sensitive to all colors of light, so it is possible to have a dim amber, OC filter, or pale green light (the "safelight") on while you print. Arrange the safelight so that it illuminates an area between the wet side and dry side. If you are working in the bathroom,

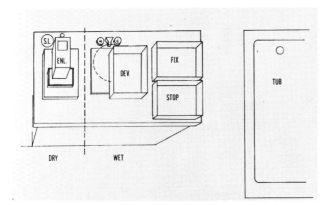

Fig. 3-13. An overhead view of the bathroom darkroom of Fig. 3-12. The broken line indicates the separation between the dry and wet sides; a board was placed over the sink to make a continuous counter. Although the trays should be aligned, a compromise had to be made in this case.

Fig. 3-14. In this bathroom darkroom no counters existed, so a simple plywood shelf was installed using a 2" × 4" piece of wood fastened to the wall at each end to support the shelf.

you can try reflecting the safelight from the bathroom mirror so that it provides a uniform glow over the room.

The most natural direction in which to work is from left to right, so arrange things to follow this pattern. For example, have the enlarger and related equipment on your extreme left, then have the developer, stop bath, and fixer going to the right, ending with the water (sink, tub, or bucket) on the extreme right. Never place equipment on the floor, because this is a guaranteed way to damage apparatus or spill trays; instead, try to keep everything at waist level. You may want to work from a chair or stool, a good way to avoid back and leg fatigue.

As it happens, the bathroom or kitchen does not always lend itself to good darkroom layout, particularly in terms of counter space. You may find that the wet side–dry side dichotomy is followed more in spirit than in practice. If usable counter space is interrupted by a sink or stove, cover the offending appliance with a piece of plywood in order to obtain a single, continuous counter.

Where no counters exist you will have to provide them. Folding counters are particularly convenient because they are inconspicuous when not in use. Many hardware stores stock special brackets that can be locked into a rigid upright position, or collapsed so that the counter they support lies flush with the wall. Sometimes a simple folding table or card table will be all you need. Consider space and counter availability in addition to light-proofing before finally selecting a room.

Although kitchens have a sufficient number of electrical outlets for working, bathrooms and storage or laundry rooms frequently do not. In a bathroom, the only available outlet is usually tied into the main lighting fixture, which means that you can only obtain electricity for the enlarger and safelight when the wall switch is in the "on" position and the room lights are on. You could, of course, unscrew all of the light bulbs from the wall fixture, but then you would have no normal room lighting, needed for print evaluation later. A better solution is to bypass the outlet on the lighting fixture by bringing in an extension cord from another outlet in a different room. In this way you will have both room illumination and safelight illumination as you need them.

4
An Introduction to Making Prints

You may eventually decide to make photographic prints at home when you realize that film developing is only one aspect of the total photographic process. You could, of course, make negatives at home and select a few frames for commercial printing. This won't be much cheaper than having the roll of film commercially processed from the start—the commercial developing and contact sheet are quite reasonably priced. Each 8" × 10" enlargement, however, may cost between $1.50 and $2.50, and, if custom printed to your instructions,

even more. The equivalent prints made at home average only 15 or 20 cents apiece. The price of commercial processing reflects labor costs and convenience, not the price of materials alone. If you cannot afford the amount of time taken up by processing at home, the more expensive commercial processing may prove a saving by convenience.

As was the case for film processing you do yourself, the primary argument favoring home print processing remains control. Control means

Fig. 4-1. A contact print can be no larger than the negative from which it is made.

that you can take time to give your prints and negatives the care and attention to detail necessary for the creation of genuinely special photographs. The corner drugstore is not in business to create art; their services are fine for the average snapshot, but not for more serious photography.

I feel it would be helpful to pause again for some theoretical background before actually tackling printing.

THE PHOTOGRAPHIC PRINT

A print is simply the reversed image of a negative on paper—a positive image. In fact, the very first photographs used no negatives at all; they were obtained by placing a piece of chemically sensitized paper at the back of the camera and then exposing it to light. Of course, this made a picture on paper with the light and dark values reversed from those of the real world, a picture that we now call a "paper negative." Not very useful I suppose, but a start. The goal remained to generate a photographic positive, but it took some time before anyone devised practical means to accomplish this. The system we use today follows one conceived in the mid-nineteenth century: A photographic emulsion is deposited on a transparent substance, such as glass, celluloid, or acetate. It is then placed in the camera, exposed to light, and it records an image existing in the environment. The resultant piece of film, the negative, is then processed. The processed negative is placed on a second emulsion, this one deposited on paper, an opaque substance, and light is passed through the negative where it exposes (darkens) portions of the second emulsion. When chemically processed, the second emulsion has light and dark values which correspond to those of the real world. Therefore the second exposure is called a *positive,* and if the positive is on paper it is called a *print* (if the positive is on a second transparent substance it is called a *transparency).* Even though we now have direct positive film processes, most photographs are still produced by the negative–positive system.

Early photographers were more limited in their printing techniques than we are today. Most often the negative was simply secured to a piece of printing paper and exposed to light. Such a print is called a *contact print* because the negative is placed in physical contact with the printing paper. Early contact prints had several distinct advantages and disadvantages. Because no magnification of the negative was involved in the process, remarkably fine-grain characteristics were obtained. The technique was relatively easy to learn and did not require an extensive amount of equipment. On the other hand, the size of the negative dictated the size of the print. This meant that one had to have a fairly large camera in order to produce a large negative, and thus a large print. If one wanted to eliminate a portion of the negative in printing, then he had to reduce the size of the eventual positive in the bargain. It was not until the invention of the photographic enlarger that the inherent disadvantages of contact printing were overcome, and, as we shall see, some of the advantages as well.

ENLARGING

The enlarger is a device which enlarges a relatively small negative or portion of a negative into a bigger image. The most immediate consequence of the invention of the enlarger was that photographers could use a small film format, and therefore a smaller camera, than had been necessary for contact printing alone. In addition, the enlarger permitted the blocking out, or *cropping,* of portions of the negative while maintaining the desired size for the finished print.

But the enlarger also has it own inherent disadvantages. The chief disadvantage is that the en-

Fig. 4-2. The enlarger allows you to make a big print from a small negative.

larger increases the size of individual emulsion elements (grain) as the print size grows, increasing the probability that grain will be obvious in the finished print. The smaller the negative or the larger the size of the finished print, the greater will be the graininess. Consider too that enlargers and their associated equipment can be quite expensive, a second disadvantage. The third disadvantage of an enlarger is more subtle: an enlarger may make picture-taking habits sloppy because you may feel that it's possible to compensate for shortcomings in the negatives when you print. This is not generally true.

The development of practical photographic enlargers was a central element in the evolution of modern photographic technique. Because they permitted the photographer access to virtually any situation with his new smaller cameras, their use quickly spread. The photographer was also freer to compose his pictures in the darkroom, another very important development.

CAMERA AND ENLARGER

In some ways an enlarger is a camera in reverse. The camera is a device for reducing a large pattern of light seen in the environment to the small pattern recorded on the negative. The enlarger makes the image contained within the negative larger.

Let me briefly explain some optical properties of the camera and enlarger so that you will be able to take fullest advantage of the enlarger, see its relationship to the camera, and know what to look for when buying an enlarger.

Fig. 4-3. When viewed in profile, a convex lens appears "fatter" in the middle than at its edges.

Lenses

The most common lens in photography, either singly or in combination, is the *convex lens.* In profile a convex lens appears fatter in the middle than at the edges. All lenses bend or "refract" light traveling through air in characteristic ways, but the convex lens has the following special characteristics:

Fig. 4-4. A condensing lens is really just an exaggerated convex lens with an extremely short focal length.

1. Light rays from a distant object pass through the convex lens, and if we place a flat surface behind the lens, a pattern of light duplicating the object will be formed. The reconstructed pattern of light on the surface is an *image,* and the light from the object has been *focused* by the lens. The place where the image is formed is called the *focal plane.*

2. The image will be reversed in the left–right and up–down dimensions in relation to the real object.

3. The distance from the center of the lens to the focal plane is called the *focal distance.*

4. If instead of a surface, we place a second convex lens at the focal point, then the light passing through it will no longer converge to form an image, but will diverge or *collimate* into a uniform beam.

The earliest cameras used a simple convex lens but much more complicated systems soon evolved. Today what we call a "lens" is actually composed of many single lenses in combination. For illustrative purposes though, we can imagine that this complex series of lenses is actually a single convex lens.

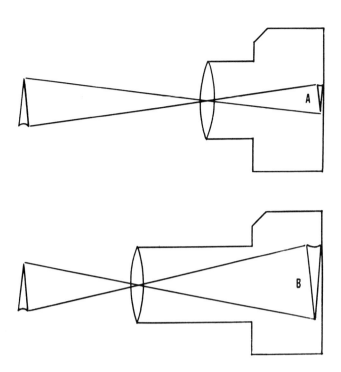

Fig. 4-5. All other factors being equal, the shorter the focal length of a lens (A), the smaller the image size. A longer focal-length lens (B) produces a larger image.

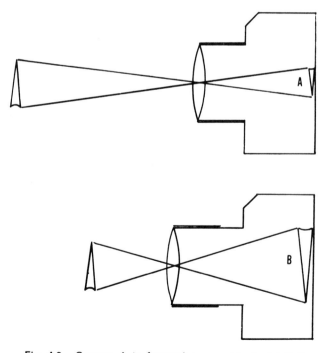

Fig. 4-6. Camera A is focused on an object at infinity. As the object approaches the camera (B), the lens must be moved outward slightly in order to keep the object in sharp focus.

In the camera the focal length of the lens printed on the front of the lens tube is correct only when forming an image of an object at "infinity," a distance which, for all practical purposes, is any greater than about 100 feet. As the focused object comes closer to the camera, the focal length must be increased. This means that in order to keep an image at the original focal plane (in this case, where the film is) the lens must be moved slightly away from the camera. What you do when you "focus" your camera is increase the focal length of the lens for objects closer to the lens than infinity.

Cameras come equipped from the factory with so-called *normal lenses*. A normal lens has a focal length approximately equal to the diagonal of a single frame of film in your camera. For example (and don't let the numbers frighten you), a single frame of 35mm film measures 36×24mm, which makes the diagonal of the rectangular frame approximately 45mm. The normal lens for a 35mm camera has a focal length of about 50mm for an object at infinity. The normal lens, as it happens, is one which includes about the same area of a scene as you see normally. Because it can focus on objects quite near the camera as well as those very distant, the normal lens is considered a good choice for general use.

A camera lens with a typically shorter focal length will include more of a scene than the normal lens and is therefore called a *wide-angle* lens. This

Fig. 4-7. The so-called "normal" lens is calculated from the diagonal of a single frame of film. The ruler illustrates that 35mm film has a diagonal of approximately 50mm.

Fig. 4-8a and b. (Left) This bulldozer engine was shot at *f*/2. The cylindrical objects in the center were focused on but the limited depth of field caused background and foreground objects to blur. (Right) This same scene was shot at *f*/16. Notice how more objects at different distances are in sharp focus.

lens is good to use for taking pictures of broad landscapes or architecture, when you wish to include a large portion of the scene. A lens with a focal length longer than that of the normal lens will magnify the image and, logically, include less of the scene in the picture than would a normal lens. Such *telephoto* lenses are useful to have when you can't get close to your subject but still want the subject to fill the picture.

Depth of field

When you focus on an object with your camera, it is reasonable to assume that the object will be sharp, while objects in-front-of and behind the central object will be fuzzy, *i.e.*, poorly focused. This is not absolutely true. (Imagine the kinds of pictures we would take if it were true.) The degree to which objects around the focused object also appear in focus depends upon the depth of field your camera creates. Weak or strong depth of field is a function of the aperture and focal length of the lens. For present purposes I'd rather not go into a complicated technical explanation of depth of field; simply remember that the larger the aperture, the smaller the depth of field. For example, more objects in front of and behind the principally focused object will appear clearer when the aperture is set at *f*/22 than when it is set at *f*/2.8. Now you should be able to see that the aperture regulates two functions: the amount of light entering the camera, and the depth of field.

Lenses affect depth of field because depth of field is also a function of the focal length of the lens. In this case the rule is: The shorter the focal length, the greater the depth of field will be. This means that, all other factors being equal, a 28mm lens will provide better depth-of-field relationships than a 100mm lens.

The enlarger

The principle of the enlarger is to magnify an illuminated negative. The illumination of the negative must be even in order for the enlarger to be effective. You could place a light source, such as

Fig. 4-9. An internal diagram of an enlarger shows that light emitted by a lamp (A) is collimated by the condensers (B) in order to illuminate the negative held in the carrier (C). The lens (D) then focuses the illuminated negative's image onto the baseboard (E).

40

an incandescent bulb, behind the negative with a piece of milky glass between lamp and negative to diffuse the light. Unfortunately, this method does not produce a very powerful illumination for the negative and does not always distribute the light evenly over the entire surface of the negative.

A better system places two convex lenses between the lamp and negative, so that the light is collimated into a strong but uniform beam. Lenses used for this purpose are very "fat" in the middle, have extremely short focal lengths, and are called *condensers*. Sometimes the lenses together are referred to as the condenser. The condenser merely provides a reliable way to illuminate the negative evenly.

Below the negative is a magnifying lens that projects the image of the negative onto a flat surface beneath it. The double condenser and magnifying principle, by the way, is also used in the slide projector.

Enlarging lenses share certain similarities with camera lenses. There is such a thing as a "normal" enlarging lens. For example, a 50mm lens is considered normal for both the 35mm camera and 35mm enlarger although the two devices use different 50mm lenses. If your film format measures 2¼" × 2¼", a 75mm or 80mm lens is considered normal on the camera and the enlarger. The normal lens permits you to enlarge a print to about 11" × 14" with an average enlarger. Similar to camera lenses, enlarging lenses have apertures, but because the flat image has only two dimensions, depth of field is a secondary consideration to light regulation in the enlarging lens. Good enlarging lenses, in fact, are designed to project as flat a field as possible.

The enlarger, like the camera, must be focused when the distance between negative and focused image is changed. In the case of the enlarger, altering the distance between focused image and negative will cause changes in the size of the focused image (the more distant the enlarger is from the focusing plane, the larger the image), but of course the focal length of the lens will need adjustment as it is moved toward and away from the projected image. Because the enlarger magnifies the illuminated negative, it is possible to maintain the size of the finished print even though only part of the negative is used, *i.e.*, you simply magnify a portion of the negative by a power greater than would have been used had the entire negative been printed. In essence, this is what is meant by *cropping* a picture.

THE IDEAL ENLARGEMENT

Ideally, the best pictures are those which could have been made as contact prints if we were still living in pre-enlarger days. Keep in mind that the principal function of an enlarger is to permit us to use smaller cameras. A picture should be composed when you actuate the camera's shutter, not after the negative is made and printed. Every time you make a picture needlessly big and use an enlarger to enlarge a tiny portion of a negative to gigantic proportions, you run the risk of decreasing picture quality by increasing grain. In short, I think you will find that you will make your best prints from negatives carefully planned when the picture was taken.

A good print requires all of the care you have shown for good negatives, and a failure anywhere along the way will cause the end product, the print, to be less than you had wanted.

BUYING AN ENLARGER

Must you buy an enlarger? Certainly not. Many of the techniques needed to print are demonstrated in making a proof sheet (Chapter 5), so hold off for a while until you determine that printing is really for you. Don't buy an enlarger until you're quite certain you want to get seriously involved in printing. But when you are ready, here are a few things to keep in mind before putting money into a potentially costly piece of equipment.

Inexpensive enlargers are not always bad; in fact, many of them are quite good, particularly for the part-time photographer. Look for real bargains in special sales at camera stores. You might also watch for a good used enlarger often advertised in the classified section of the newspaper; just be careful not to get stuck with an absolute piece of junk, new or used. The trick is to buy an enlarger that will meet your needs at a reasonable price.

A broad consideration should be the reliability of the store from which you buy. This can only be determined by the haphazard process of asking other people who have bought things there, speaking to the salesmen, or, as a last resort, calling the Better Business Bureau. Will the store give a cash refund or only a credit? Are the salesmen helpful and are they willing to correct mistakes? Especially, note whether the enlarger (or any piece of expensive equipment for that matter) comes with a guarantee. How long will the guarantee be honored? Who does the repairs, the store or the manufacturer? Must you pay shipping 41

charges if the item has to be sent to another city for repairs? Does the guarantee cover the cost of parts and labor? In brief, take a few minutes to investigate before you buy so that you won't get stuck later, as the author has from time to time. If you're buying from a private party, ask him to put in writing all of the defects he knows the enlarger to have, and a period of time during which he will pay for repairs he may not have told you about.

The components of an enlarger and what to look for

The enlarger consists of the *head,* which contains the condensers, lens, and film carrier, plus their controls, a vertical *column* along which the head is moved, and a *baseboard* upon which the projected image is directed.

Within the enlarging head, pay particular attention to the lens, its focusing control, the negative carrier, and the mechanism by which the head is raised or lowered. Sometimes the lens is not included in the price of the enlarger, so be sure to find out before you buy. It's impossible to check the optical properties of the lens in the store; ask if it can be returned or exchanged after you have tested it at home. While in the store, check the mechanical operation of the lens by holding it up to the light and turning the *f*/stop ring from the smallest to largest stop a few times. The aperture must appear uniform at every stop; an asymmetrical aperture indicates an internal mechanical fault. After you've taken the lens home, make some prints from a good quality, detailed negative and examine the prints carefully. Details should be crisp at many different aperture settings, particularly toward the edges of the print. Better enlarging lenses have larger apertures (smaller *f*/ stops), as do better camera lenses, to make focusing easier. A decent enlarging lens has its smallest stop at *f*/4.5 or less.

Impartial test data are available from time to time in some photography magazines, although I trust the data found in *Consumer Reports* more consistently. Interestingly enough, these tests sometimes show that certain inexpensive lenses are the optical equals of higher priced ones. I feel that a good quality lens will often overcome the shortcomings to be found in some bargain enlargers.

The negative carrier holds the negative flat and at right angles to the axis of the lens. Be sure the carrier is steady and does not wobble. There are two types of carriers, glass and glassless. The glassless carrier consists of a removable metal framework in which the negative is placed, whereas a glass carrier sandwiches the negative between thin pieces of glass. The glassless type is good because dust cannot adhere as it can with a glass carrier. However, unless a glassless carrier is well-made, the film can buckle slightly causing sharply defined portions of the negative to be out of focus on the finished print. If you think you will be doing 35mm enlarging exclusively, a glassless carrier will be fine. Glass carriers should be used with larger negative formats, which are more difficult to keep flat in a glassless carrier. While in the store see which carriers are easier to operate and which are more difficult.

If I were to select the two most essential features to evaluate when buying an enlarger, they would be lens and carrier. The quality of the carrier or lens, however, is not necessarily a function of the price of the enlarger.

Next, check the mechanical operation of the head. Is the coarse adjustment, which moves the head up and down, easy to operate or do you have to fiddle with it? How about the fine adjust-

Fig. 4-10. When viewed from the outside, the enlarger clearly shows the head (A), coarse adjustment (B), fine adjustment (C), lens (D), column (E), and baseboard (F).

ment that moves the lens up and down? Is the adjusting mechanism smooth and continuous or is it jerky?

Finally, check the overall workmanship. Do parts fit together well and are they properly finished? The more expensive enlargers tend to have the best combinations of the features I have described. One way to keep the cost of your enlarger down is to determine in advance what film format you will be using; enlargers made just for 35mm negatives, for example, are cheaper than equivalent models that accommodate larger negative sizes also. In fact, several of the better manufacturers are making reasonably priced "miniature" enlargers specifically for 35mm film users. The cost of an enlarger may also be increased when the manufacturer builds in special features such as a filter drawer (you can probably do without it very well), or an internal-focusing device. I bought an enlarger with an automatic-focusing feature that I have found to be more trouble than it is worth.

One last item; you may notice that some enlarger heads are rounded whereas others are square. The rounded types have all of the optical components aligned vertically while the square types "bend" the optics by placing a mirror at a 45° angle between the condenser and lens. This feature gives the enlarger a neater appearance and makes it more compact, but in terms of optical quality the two designs are the same.

Just about any enlarger will make better prints than the drugstore's. Simply remember that in the end you must decide which enlarger is most appropriate for your needs.

5
The Proof Sheet

When I show people how to print, I usually begin by demonstrating how a proof sheet is made. A proof sheet is a contact print made by placing a set of negatives against a piece of photographic paper, exposing it to light, and chemically processing the paper. Normally a single piece of 8" × 10" paper is used, a standard size that needs no cutting.

Contact printing requires no fancy equipment (no enlarger for example), but does illustrate the basic techniques required for all printing: contact or enlargement. The finished proof sheet is a handy, positive record of your negatives and should be saved for future reference. In fact, a proof sheet should be made for every roll of film you process, but I'll explain why a proof sheet is so valuable after you've learned to make one.

WHAT YOU WILL NEED

Light source

In order to expose the photographic paper, you will need a comparatively weak light source. If you own an enlarger, then you can use the optical system of the enlarger for a light source. If you don't have an enlarger, use a small (5W maximum) light bulb—the smaller, the better. The bulb should be screwed into a socket with a switch so that you can quickly turn it off and on. A small night light plugged into an extension cord should do the job. If electrical work at this level still mystifies you, have the man at the hardware store help you. It's really quite simple.

Chemicals

Paper developers are different from film developers, except for so-called "universal" developers, which I've already downgraded. The most popular paper developers include Kodak Dektol and Selectol, Acufine's Printofine, FR Paper Developer, and Ethol LPD. The differences between developers are in their form (Dektol is a powder concentrate, for example, while LPD is a liquid concentrate), and the tones they produce in the print. You may hear one developer referred to as a "warm-tone" developer, and another as a "cold-

tone" developer, but I'm afraid this notion may be somewhat elusive to the beginner. Roughly speaking, tone is a contrast concept attributable to both the paper and the developer you use. Cold-tone prints tend to be of strong contrast with distinct blacks, grays, and whites. Warmer-toned prints tend to have a more subdued quality and often appear brownish rather than starkly black. Personally, I like Dektol because I favor the colder tones it produces and because I find it widely available but I encourage you to experiment until you discover a particular paper and developer combination that pleases you.

Use exactly the same kind of stop bath and fixer for paper that you previously used for film. Be certain, however, that you use different *batches* of chemicals for film and paper, and make absolutely sure you don't use the paper stop and fixer for film. Why? Paper chemicals, with the exception of developer and stop bath, can be reused, whereas film chemicals generally cannot. Used paper chemicals have been weakened slightly and contain impurities which, while they won't affect prints, may very well spot the negatives. So you should now have two entirely separate sets of each type of chemical, one for film and one for prints.

Photographic paper

Paper for prints is categorized along several dimensions, some of which immediately concern us, and some of which will be better considered when we discuss enlarging. Print paper is manufactured in a number of standard *sizes,* including 5" × 7", 8" × 10", and 11" × 14", although some others may be found. For most purposes, 8" × 10" paper is widely used. It's cheaper, incidentally, to cut down 8" × 10" paper to obtain 5" × 7" sheets than to buy the smaller size already cut. Proof sheets are printed on 8" × 10" paper.

Paper also comes in two *weights,* called single weight and double weight. Single-weight paper has the feel of strong typing or wrapping paper, while double-weight paper has substantially more substance, approximating very light cardboard. Single-weight paper may sometimes bend in processing,

causing unattractive blemishes on the surface of the print; double weight rarely does this. Double weight is also not so prone to curling and buckling after drying, and some people find it easier to mount. The one big *disadvantage* of double weight is that it's considerably more expensive than single weight paper, perhaps a dollar more per 25-sheet pack. In your case, because you're just starting out, I recommend double-weight paper because it's much easier to work with. After you have the hang of things, save yourself some money by buying single weight.

Paper is also classified according to the *finish* of the dried print. The broadest division here is between paper with a glossy finish and those having a matte finish. I'm sure you've seen glossy prints with their bright reflective coatings (prints from the drugstore are "glossies"). Matte finishes may vary from a simple non-relecting surface to a highly textured one, including finishes resembling sand, brushstrokes, fabric, and fine pebbles. Kodak classifies the finishes of their paper by a system of letters, *e.g.,* an "F" paper is glossy, "N" is flat matte, "R," "X," and "Y" are highly textured. The other large manufacturer of paper, Agfa, uses a different system. Their glossy papers are identified by a single digit, as in "Brovira *1*," while other surfaces are indicated by multiple digits, such as "Brovira *119*." You'll catch on to this soon enough, but if you're confused, have the salesman help you or look for a small reference book. Such books are provided by the manufacturers to show how the different paper finishes can be identified. For proofing, a good quality glossy finish is recommended.

Yet another quality of paper, *tone,* has also been mentioned. Although tone is partially dependent upon the developer, it is largely a function of the paper. Warm-tone papers are identified by name, *e.g.,* Kodak *Ektalure* and Agfa *Portriga Rapid,* as are colder-toned papers like Kodak *Kodabromide* and Agfa *Brovira.* Use a cold-tone paper for your proof sheet because it will show detail more clearly.

Finally, paper is identified by *contrast grade,* shown somewhere on the paper package by a single number from one to six. The particular contrast grade you will need is a function of the density of your negatives. If the contrast of the negatives is normal, showing nice blacks, grays, and clear portions, then use a No. 2 paper. All of the other grades are intended to compensate for deficiencies in the contrast quality of the negative. In most cases it isn't necessary to use the extreme grades (Nos. 1 and 6), but if negatives tend to be very dense, No. 1 paper will compensate somewhat because it stresses gray tones. Paper grades Nos. 3 to 6, however, tend to emphasize black and white and are used when negatives are thin. The contrast grade of the paper is really only an important consideration when the print is an enlargement, not a contact print. For contact prints, No. 2 paper will produce acceptable prints despite large discrepencies in negative density; even No. 3 paper will usually be fine. In addition, you can't transform a dreadful negative into a breathtaking print simply by selecting a different grade of paper. In short, paper grade choice won't be much of a factor until you have to enlarge.

Because my aim is to simplify, not confuse, I'll now *tell* you exactly what to buy when you go to the store. I like papers by Kodak and Agfa; because they are the most readily available, I'll limit my selections to these. Buy either 25 sheets of No. 2, 8" × 10" Kodabromide F, double weight, or 25 sheets of No. 2, 8" × 10" Agfa Brovira 11, double weight. Notice, by the way, that these are *enlarging papers,* not *contact papers.* There are papers specifically intended for contact printing (such as Kodak Azo), but because enlarging papers will work equally well for our purposes, why burden yourself with such specialized materials? Enlarging paper is used for both simple contact prints and enlargements.

There are also papers called "polycontrast" which have no indicated contrast grades. The polycontrast system uses a single type of paper whose contrast is varied by changing the color of light striking it through one of several filters. Although a number of people use this system in order to avoid buying many different contrast grades of paper, I dislike the system for a variety of reasons. One reason is that buying the filters is a hefty investment. So, unless you already have a set of polycontrast filters, don't buy polycontrast paper.

Trays

The three basic chemicals (developer, stop bath, and fixer) are poured into plastic print trays. The size of the tray will limit the size of the print you'll be able to process, so buy trays that measure at least 8" × 10", although 11" × 14" trays are preferable. An 8" × 10" print can be most easily manipulated in a larger tray, say, one intended for 11" × 14"s. Check first to see if your counter space will accommodate the trays, remembering

that an 8" × 10" tray is actually slightly larger than the print. Trays should have distinct grooves along the bottom so that you'll be able to lift the print off the bottom of the tray. When you bring your trays home, mark one "developer," a second "stop," and the third "fixer." A grease pencil will make good marks.

Fig. 5-1. An inexpensive but effective contact printer can be made by attaching a piece of cardboard to a glass square with a strip of tape.

Contact printer

A contact printer is a device for holding the negative in close physical contact with the paper during the period when the paper is exposed to light. Fancy contact printers cost about $10, but a simple and effective printer can be made for about one dollar. Buy a piece of window glass which measures at least 11" × 14" and tape one side of the glass to a piece of cardboard of the same dimension so that the tape acts as a hinge between glass and cardboard. Then cut out a small semicircle from the edge of the cardboard opposite the taped hinge so that you can readily lift the glass off the cardboard when the device is flat and the glass is on top. Note that this sort of glass has sharp edges, but if you buy it from a glass cutter he'll smooth the edges at no extra charge.

Tongs

The printing paper is transferred from one tray to another using tongs, *not fingers!* I know it's tempting at first to just stick your hands into a tray, but deny the temptation. Those fingers soaked in developer or stop bath are an easy source of contamination for your unexposed paper. *Always* use print tongs. I like the cheap bamboo tongs which have soft, rounded rubber tips. Unlike some plastic or steel tongs, rubber-tipped bamboo tongs are not likely to scratch the surface of a print or gouge

a hole. It's true that they wear out sooner than other types, but they're so cheap they can easily be replaced. You will need two pairs of tongs, one with red tips and one with blue tips. The red ones will be used between the first and second trays and the blue, between the second and third.

Miscellaneous

You'll need a clock or watch with a sweep second hand for timing exposures and development, and a piece of cardboard measuring about 5" × 7" or a Kodak Projection Print Scale in order to determine exposures. Equipment for finishing the print is discussed in a separate chapter.

Altogether, this equipment should cost about as much as the film processing equipment used earlier, probably less than $20, not counting the cost of an enlarger.

PREPARATION

Arrange the equipment in production line fashion with the light source to the extreme left, then developer tray, stop, and fixer going to the right. Place a pair of tongs beside the developer tray and a second pair beside the stop-bath tray. The contact printer, paper, negatives, and exposure device all belong on the dry (left) side with the light source, as far away from the chemicals as possible. Arrange the safelight so that it illuminates as much of the wet side as possible, making certain that the safelight cannot come into contact with the liquids.

If you are using an enlarger, set the f/stop on the lens to somewhere in the middle of its range, approximately f/8. Now turn off the room lights for a minute, turn on the enlarger, and crank up the head until the light falls on the entire contact printer, even a little beyond if you wish to be on the safe side. If you're using a weak light instead of an enlarger, try to rig it so that you don't have to hold it in your hand all the time. The light should be about four feet above the surface of the contact printer.

Fill the trays. An 8" × 10" tray will comfortably hold 1 or 1½ quarts of liquid; more than this amount may slosh over the sides of the tray, but less may not cover the paper. A tray intended for larger prints, 11" × 14" for example, will hold at least twice this amount. Most paper developers are first prepared as stock solutions that must be further diluted into working solutions, whereas stop baths and fixers can usually be used directly from the stock preparations.

Assuming that the room has been properly light-proofed, you are now ready to print.

Fig. 5-2. Clean both sides of the glass with a window cleaning preparation.

DETERMINING EXPOSURE

STEP 1: *Clean the contact printer.* Using a household glass cleaner, such as Windex, carefully clean both sides of the glass. If you work neatly, this only has to be done once per printing session. Remember that dust particles, smudges, and fingerprints on the glass will print.

STEP 2: *Remove the negatives from their envelope.* Place them in a pile on the dry side, all facing the same way.

Fig. 5-3. Stack the negatives near the printer.

STEP 3: *Turn off the room lights.* The only source of illumination should now be the safelight.

STEP 4: *Expose a test strip,* which can be done in either of two ways:

Fig. 5-4a. Turn off the room lights. A simple test strip is made by first cutting an 8" × 10" sheet of photographic paper into four strips.

Method 1

Remove a sheet of 8" × 10" paper, and using a pair of scissors, paper cutter, or razor knife, cut the piece of paper into four strips of equal size.

 a. Place the remaining paper and all but one strip (the rest will be used for future test strips) back in the protective package. Make sure you have tightly sealed both the inner and outer envelopes of the package.

Fig. 5-4b. Place a single negative on top of a paper strip, emulsion side to emulsion side.

b. Open the contact printer and place the strip of paper on the cardboard backing with the emulsion side of the paper facing up. The emulsion side is shiny and usually curls inward.
c. Place a single strip of negatives in contact with the paper. The emulsion side of the negative (the dull side) should be in contact with the emulsion side of the paper. Close the printer.

Fig. 5-4c. Close the printer and cover all but a small portion of the strip with a piece of cardboard. Turn on the light source and start timing.

d. Place a piece of cardboard over the film-paper combination so that about one inch of the paper is uncovered.
e. Turn on the light source and start the clock (or start timing) simultaneously. The light must remain on for precisely 60 seconds.

Fig. 5-4d. Move the cardboard down the strip, exposing additional small portions at 10-second intervals. At the end of 60 seconds, turn off the light source.

f. While the light source is on, move the cardboard down the test strip at ten second intervals, exposing about an inch more of paper to the light each time. This will yield six different exposures within the minute interval.
g. Turn off the light at the end of 60 seconds, open the printer, return the negative to its pile, and chemically process the test strip (step 5, below).

Fig. 5-5a. Still another way to expose a test strip is to use a Projection Print Scale. Begin by cutting a sheet of photographic paper into four rectangles with the room lights off.

Method 2

Remove a sheet of paper from its protective packaging and cut the sheet in half along the short dimension and along the longer dimension to make

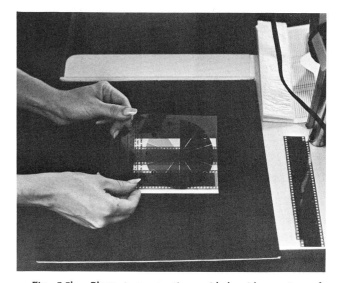

Fig. 5-5b. Place two negatives side-by-side on top of the paper, paper emulsion facing the negative emulsion, and place the print scale on top.

four rectangles (not strips). Replace the paper and all but one rectangle in the package.

a. Open the printer, place the rectangle with emulsion side up on the cardboard backing and place one or two strips of negatives emulsion side down on the paper.

b. Place the Projection Print Scale over the negative-paper combination and close the glass. The printer should now enclose the paper, negative, and print scale.

Fig. 5-5c. Close the printer and expose this sandwich of materials to light for 60 seconds.

c. Expose the paper-negative-print scale sandwich to the light source for exactly 60 seconds.
d. Turn off the light at the end of the 60 second interval, return the negative to the pile, place the print scale aside, and process the exposed rectangle chemically (See STEP 5).

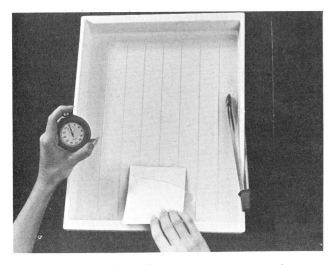

Fig. 5-6a. To chemically process a test strip, first immerse the exposed paper in the developer. Try to get it all under the surface of the liquid at once.

STEP 5: *Immerse the test strip in the developer,* trying to get it all under the surface of the liquid as quickly as possible. Use the first set of tongs to get the last bit of the paper into the developer.

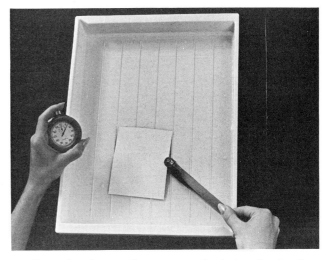

Fig. 5-6b. Agitate the paper gently during the development period of 60 or 90 seconds.

STEP 6: *Start timing the development of the paper.* Most papers must be fully immersed in the developer for *at least 60 seconds,* some for 90 seconds—check the instructions packed with the paper beforehand.

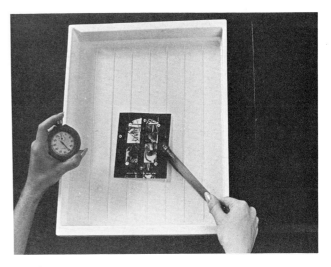

Fig. 5-6c. The scale will emerge during development.

STEP 7: While the paper is developing, *grab the edge with the tongs and agitate the paper gently* by moving the paper slowly back and forth in the developer.

STEP 8: *Lift the paper out of the developer with the tongs* at the end of the development period, and let the excess developer drain back into the tray.

Fig. 5-6d. The strip is then placed in stop bath for about 30 seconds with mild agitation.

Fig. 5-6e. Finally, immerse the strip in the fixer and leave it there for 5–10 minutes.

STEP 9: *Slide the strip into the stop bath* and agitate gently for about 30 seconds.

STEP 10: Using the second set of tongs, *lift up the strip, drain off the excess stop bath, and immerse in the fixer*. The strip must be completely covered with the fixer for at least 30 seconds before turning on the room lights.

STEP 11: *Turn on the room lights and evaluate the test strip*.

If you have used the first type of test strip, you should now see six distinct exposures. The lightest area represents an exposure of 10 seconds, the next area an exposure of 20 seconds, and so on until the darkest area is seen, which shows an exposure of 60 seconds. The portion which you judge to have the best contrast properties then determines the proper exposure period for the entire proof sheet.

Fig. 5-7a and b. The long strip above shows a number of exposures ranging from 60 seconds the dark area at the top) to 10 seconds. The print scale test strip (opposite page) shows a number of exposure times directly. Select a value which you feel has good contrast.

50

Fig. 5-8a. With the room lights off, slip a piece of paper into the contact printer.

The second type of test strip also shows a number of print densities. Each wedge-shaped area is numbered with the equivalent exposure time, somewhat like the first test strip. Simply select an exposure with good contrast properties and note the time (in seconds) for that wedge. If two adjacent areas appear nearly identical, I have found that the darker of the two is usually better for the entire proof sheet.

PRINTING THE PROOF SHEET

Now that you have determined the proper exposure, all you have to do is repeat the steps described above, substituting a full sheet of paper on which all of the negatives are exposed. It is important that you maintain precisely the same development time (60 or 90 seconds) for the proof sheet that you had previously used for the test strip. Remember that it is virtually impossible to judge the quality of any kind of print (test strip, proof sheet, or enlargement) in the dim illumination of the safelight. The only consistent way to obtain a good print is to keep rigid control of processing times.

The following procedure will produce good proof sheets every time:

STEP 1: *Turn off the room lights.*

STEP 2: *Remove a single sheet of 8" × 10" paper from the package* and carefully replace the remaining paper.

STEP 3: *Lift the glass of the contact printer and place the paper on the cardboard backing with the emulsion side up.*

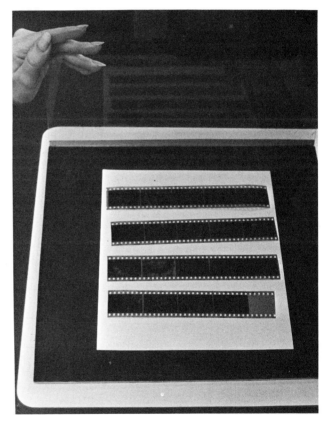

Fig. 5-8b. Arrange the negatives on top of the paper and close the printer.

STEP 4: *Arrange the negatives neatly on the paper,* with the paper emulsion touching the negative emulsion. A single sheet of 8" × 10" paper will accommodate a maximum of thirty-six 35mm exposures (in six frame strips), or twelve 2¼" × 2¼" negatives cut into three frame strips.

STEP 5: *Turn on the light source* for the time interval previously determined by the test strip.

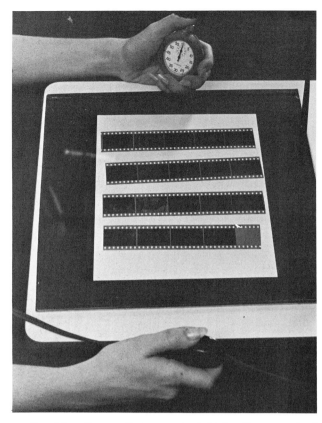

Fig. 5-8c. Expose the paper to light for the amount of time determined by the test strip.

STEP 6: *Open the printer*, set the negatives aside, and *immerse the exposed paper in the developer*. Again, try to slip it into the liquid in a single motion and agitate gently during the development interval.

STEP 7: *Remove the developed proof sheet*, drain for a few seconds, and *place it in the stop bath* for 30 seconds or so.

STEP 8: Using the second set of tongs, *lift the*

Fig. 5-9a. Immerse the exposed paper in the developer.

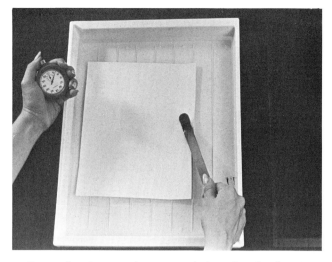

Fig. 5-9b. Agitate the paper during the development interval exactly as the test strip had been developed.

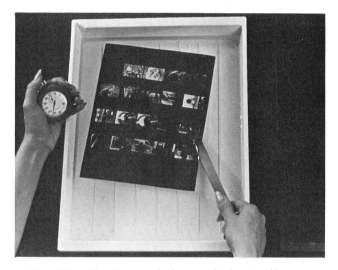

Fig. 5-9c. The image of the proof sheet will emerge during development.

Fig. 5-9d. Place the proof sheet in the stop bath for about 30 seconds with mild agitation.

Fig. 5-9e. Immerse the sheet in the fixer solution for 5–10 minutes.

paper from the stop bath and immerse fully in the fixer.

STEP 9: After 30 seconds of fixing time, *turn on the room lights and examine the proof sheet.* Keep the print fully immersed in the fixer, however, for at least five minutes even though the room lights are on.

STEP 10: After the print has been fixed, *place it in water.* Use the bathtub, sink, or a tray or bucket filled with water.

STEP 11: *Wash and dry the proof sheet.* Refer to Chapter 7 for detailed instructions.

HOW TO USE A PROOF SHEET
Whatever you do, don't throw away the proof sheet. It isn't a pointless exercise in introductory printing, but serves a number of valuable functions.

Fig. 5-10. You may turn on the room lights and examine the proof sheet while it soaks in the fixer. The sheet will be washed and dried after fixing.

Fig. 5-11. Proof sheets should be numbered to correspond to negatives, and may be stored in a looseleaf binder for future reference.

For one thing, the proof sheet is a permanent record of your negatives. This will be particularly important as the number of negatives you produce increases. In fact, proof sheets form the basis of a very helpful system I have developed for keeping all my prints and negatives in order. When each proof sheet has been dried, I number it to match the corresponding negative envelope. Then I put the proof sheets in a looseleaf binder with all my other proof sheets, in the same order as my file of negatives. If I want to print a negative taken some time ago, I simply leaf through my proof sheets until I find the right frame and then pull the corresponding set of negatives from my file.

A proof sheet may also save you money when you enlarge. By carefully examining the proof sheet you'll be able to select those negatives worth enlarging. If the proof sheet is a contact print of 35mm negatives, use a magnifying glass to get a better look at the prints. In this way you'll be able to see things like people's expressions, whether they have their eyes open, scratches on the negative, and so on. Experienced photographers never enlarge every single exposure on a roll. They select among their negatives to find the best or most interesting frames to enlarge.

You can also experiment with the proof sheet to see how different kinds of cropping can change the appearance of the print. You may notice that not every printed frame has the same density. This is because there were probably some variations in exposure when the pictures were taken, causing different negative densities and different overall darkness values on the printed sheet. Take note of these differences. A lighter than average frame results from a slightly overexposed negative, which means that it will need a bit more exposure when you enlarge. Conversely, a darker than average frame is produced by an underexposed negative, which will require less exposure when enlarged, compared to the rest of the negatives.

6
The Enlargement

Although proof sheets constitute an invaluable record of your photographic work, the contact print made from a small piece of film is not the sort of picture you would want to display. Even the largest film format you might use, 2¼" × 2¼", is relatively ineffective. So, at the risk of sounding trite, may I say that as the day must follow night, so enlarging must follow contact printing.

This doesn't mean that you should rush right out and buy an enlarger. Perhaps you'll find someone who will let you use his enlarger so that you can decide if you want to take the plunge. If you like print making, I'll bet you'll be hooked for life.

HOW LARGE SHOULD AN ENLARGEMENT BE?
When that special moment arrives when you show your friends or relatives your first prints, one of them is bound to say something like, "Oh, what lovely pictures, could you make me a few wallet-size prints?" Chances are that you're susceptible to idle flattery and will agree, but how big is wallet size? I must add that it usually takes only one or two of these episodes to cure such an urge to please because, as you will quickly discover, it is more trouble to make a tiny print than a substantial enlargement.

The size of the enlarged print is determined by a number of factors. First, consider the physical limitations of your processing equipment. With the setup I use, for example, I can't squeeze anything larger than 11" × 14" trays into my bathroom-darkroom, which limits the largest prints I can produce to that size.

A more important consideration, though, is the purpose of the print. If the print is meant to be enshrined in someone's wallet then it must be quite small, usually 2½" × 3". A print meant for a picture album might be a bit larger, 3½" × 5", for example. The smallest picture you might want to hang on a wall would probably be 5" × 7", although the 8" × 10" or 11" × 14" print format is better.

All of the sizes I've mentioned have in common that the proportions of the print remain roughly equal. There are other print sizes, but the ones mentioned here are most often seen, and are considered standard among photographers. Virtually any square print is also considered standard, but don't take this to mean that other formats are never used. In fact, I think you'll find it fun to experiment with many different proportions to see the effects they produce.

Even though photographers sometimes try new formats, the 8" × 10" print has become most common. The size is used for several reasons. The 8" × 10" paper requires no cutting in the darkroom because it has already been cut to size at the factory—a great convenience when you have a lot of printing to do. The rectangular shape is aesthetically pleasing and encourages many different compositions. The 8" × 10" shows detail nicely when viewed at a distance of three or four feet, but is not so drastic an enlargement that grain is a crucial factor. When I illustrate enlarging technique I'll show an 8" × 10" print.

A CLOSER LOOK AT PAPER
Throughout this chapter I will describe a somewhat restricted method for making prints because I believe it provides the quickest way to make fine enlargements. But please don't let my personal judgment stifle your creativity. For example, most often I recommend that you use glossy paper. I do this because glossy paper can be made to acquire any of several surfaces and offers the greatest latitude in terms of finish. It's still a good idea to try many types of papers, in terms of both tone and finish. The principles governing the use of different paper finishes are very loosely organized and subject to a great deal of personal interpretation, so let's think of them as approximate guidelines rather than inflexible rules.

Finish

A polished, glossy print finish is most common, even though it is not appropriate for every situation. I think that glossies are more suited to technical subjects like machines and diagrams than to nature and people. Glossies are also used for photomechanical reproduction and may be required if the photograph is to be published. Al- 55

though the reasons for this practice have never been made entirely clear to me, the procedure is followed apparently because glossy prints exhibit the most detail and stand up to rough handling better than some other finishes.

A semi-matte surface can be produced by drying glossy paper in a particular way (see Chapter 7), and is very widely used among amateur photographers because it's so easy to create. At the same time, a semi-matte finish lends itself to all sorts of subjects, from the harshest to the most refined. The semi-matte finish will be demonstrated later on.

A true matte finish can only be obtained by using matte finished paper. It should also be pointed out that *only* a matte finish can be made on this type of paper. A true matte finish tends to blur fine detail and has almost a printed appearance. Its greatest applications are in portrait work and certain kinds of nature photography, where a feeling of softness is intended by the photographer. I have used matte finish for starker subjects, however, and with a certain degree of success. As I've said before, you'll need to experiment before you're completely satisfied.

Distinctly textured surfaces, those that resemble sand or canvas or brushstrokes, are very specialized and should really be thought of as novelties. They're the sorts of finishes you see in high school "mugshots," or in overly sentimental cornball photographs. I think they're really rather silly.

Tone

Similar to paper finishes, paper tones follow no rigid categorization. Generally, soft brownish tones are used for portraits whereas colder tones are used for harsher subjects. Don't confuse the tone of the paper with a related chemical process called *toning*. A *toner* is a special dye that is applied to the paper after the print has been processed in order to impart a color to the picture. Toners vary from reddish-brown (sepia) to pastel shades of red, yellow, blue, or green. The tone of the paper that we've been talking about is built right into the paper at the factory.

SETTING UP THE ENLARGER

The darkroom is prepared exactly as it was for proof printing except that the adjustable easel is substituted for the proof printer, and, of course, the enlarger is used instead of the small light source. Continue to use the same 8" × 10" glossy paper. As before, an exposure will be established before we actually print the enlarged picture.

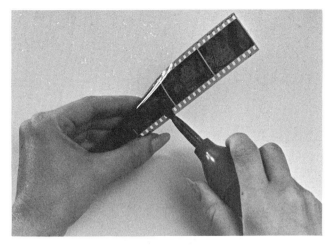

Fig. 6-1. Clean dust particles from the negative.

Fig. 6-2. Insert the negative into the negative carrier.

STEP 1: Determine which frame you wish to print by reference to the proof sheet. *Clean the negative carrier and lens* with the soft brush or blowbrush, and then *remove any specks of dust from the negative.*

STEP 2: *Place the negative in the carrier.* Always handle the negative by the edges. The emulsion (dull) side of the negative always faces downward toward the baseboard of the enlarger.

STEP 3: *Adjust the easel* to the print format you have chosen. The easel must be adjusted to measurements slightly smaller than the format of the finished print in order to form an edge which will hold down the paper. For an 8" × 10" print, for example, the easel should be set at 7¾" × 9¾".

STEP 4: *Set the f/stop of the enlarging lens to its widest aperture,* perhaps f/3.5 or f/4.5. This procedure provides the brightest possible picture, an aid to focusing. The f/stop will be changed in a later step before the print is made.

Fig. 6-3. Adjust the easel to accept the paper.

Fig. 6-4. Set the aperture to its widest adjustment (smallest *f*/number).

Fig. 6-5. Turn on the enlarger and center the image on the easel.

STEP 5: *Switch on the enlarger and focus the picture.* As you focus, compose the picture. Decide now what portion of the negative you want to crop, if any. To crop, move the head upward with the coarse adjustment knob so that only a portion of the negative actually falls on the enlarging easel.

Fig. 6-6. Bring the image into sharp focus.

Once you have selected the segment to be printed, use the fine adjustment to bring the picture into sharp focus. Work slowly and don't focus directly on the surface of the easel; instead, place a piece of paper on the easel, of about the same thickness as the enlarging paper (the back of an unwanted print is good), and focus on the paper. Make one final check to be certain the picture is composed as you want it and that it is in sharp focus. 57

Some people use a special focusing magnifier to monitor the sharpness of a few grains within the picture. A common magnifying glass, however, will do almost the same thing. In the absence of a magnifier simply watch a single fine detail within the picture, like a wisp of hair or an eyelash, until it appears sharply focused.

Fig. 6-7. Change the f/setting to an intermediate position and turn off the enlarger.

STEP 6: *Change the* f/*stop of the lens to an intermediate position,* possibly f/5.6 or f/8. The smaller aperture will allow a longer exposure than if the widest stop had been used. It will also compensate slightly for minor focusing errors because of the improved depth of field afforded by the smaller aperture.

MAKING A TEST STRIP

The purpose of the test strip is to determine the proper exposure for the enlarged print. As was the case with proof printing, there are again two ways in which this may be accomplished:

Method 1

A piece of cardboard that measures at least 5" × 7" is used. First *turn off the room lights* and remove a piece of 8" × 10" paper from its package.

Cut the paper into four strips, cutting along the widest dimension of the paper. You may have already cut strips for the proof sheet test strip, in which case simply use a precut strip. Replace the remaining paper in the package and close it.

a. All enlargers have an internal safelight filter. Put the internal safelight in place, turn *on* the enlarger and place the strip over a central feature of the enlarged image. You may have to use a small object like the scissors to hold the corners of the strip flat. Now turn *off* the enlarger and take away the internal safelight.

Fig. 6-8a. To expose the test strip with a piece of cardboard, first turn off the room lights and insert a long strip of photographic paper into the easel.

Fig. 6-8b. Turn on the enlarger and start timing. Expose successive segments of the strip at 10-second intervals for a total of 60 seconds.

b. Place a cardboard over the strip of paper, leaving about one inch of the paper exposed.

c. Turn *on* the enlarger and start timing. At ten second intervals, move the cardboard so that an additional portion of the paper is exposed. Be careful not to move the paper as you manipulate the cardboard.

d. Turn *off* the enlarger at the end of 60 seconds and chemically process the test strip (see below).

Method 2

The Kodak Projection Print Scale is used. *Turn off the room lights* and remove a sheet of 8" × 10" paper from its package. Cut the paper into four rectangles, or else use a quarter previously cut. Replace the remaining paper securely in the package.

a. Put the internal safelight of the enlarger in place, turn *on* the enlarger and position the paper, emulsion side up, over a key feature of the projected image.

Fig. 6-9b. Place the print scale on top of the paper and switch on the enlarger for 60 seconds.

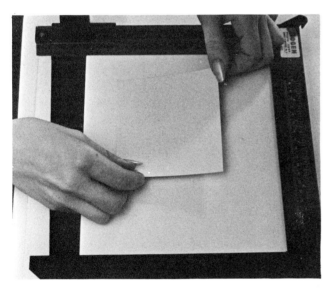

Fig. 6-9a. If you prefer to use the print scale, first place a rectangle of photographic paper on the easel.

b. Place the print scale directly on top of the rectangle. Turn *off* the enlarger. Hold the edges flat with the tips of your fingers or with any small object—be careful not to cover the wedges of the scale.

c. Remove the internal safelight and turn *on* the enlarger for exactly 60 seconds.

d. Turn *off* the enlarger at the end of the 60 second interval, set the print scale aside and chemically process the test strip (see below).

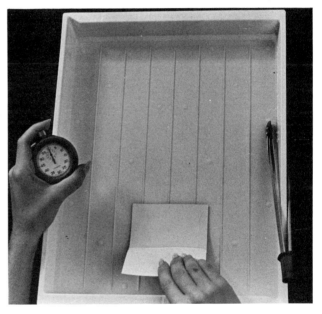

Fig. 6-10a. Begin chemical processing of the enlargment test strip by immersing it in the developer.

Follow the steps listed below to chemically process either type of test strip:

STEP 1: *Slip the test strip into the developer.* When it is completely immersed, agitate gently with the first set of tongs. Develop for exactly 60 seconds (or more depending on the manufacturer's recommendations).

STEP 2: *Remove the test strip from the developer* with the same tongs and *place it in the stop bath* for about 30 seconds.

STEP 3: *Lift the strip out of the stop bath* with the second set of tongs. Let excess fluid drain

59

Fig. 6-10b. Agitate the strip gently during development. Develop for 60 or 90 seconds.

Fig. 6-10c. Transfer the strip to the stop bath for about 30 seconds.

Fig. 6-10d. Place the strip in the fixer and leave it there for 5–10 minutes.

back into the tray, and *place it in the fixer.* After the strip has been completely submerged in the fixer for about 30 seconds, turn *on* the room lights and examine the test strip.

STEP 4: After fixing for five to ten minutes, *place the strip in water,* either sink, tub, or bucket. Because the test strip is used exclusively to determine exposure, it is not saved and further processing is not called for.

6-11a and b. The strip exposed with cardboard (left) shows exposures ranging from 60 seconds (top) to 10 seconds (bottom). The print scale test strip (above) shows a 10-seconds exposure was correct; other values appeared too light or too dark.

MAKING THE PRINT

Making an enlargement should now be easy because you have established perfect control over exposure and processing times. The exposure interval is determined by reference to the test strip. If two adjacent values both look acceptable, but one is somewhat light and the next one a bit too dark, take the average time of the two exposures and use it.

STEP 1: Check to be certain that the negative is still properly focused and that the image is free of dust. *Turn off the room lights.*

STEP 2: *Remove a sheet of paper from the package.* If for any reason you don't plan to use a full sheet, cut it now and securely replace the remainder in the package.

STEP 3: *Lift the frame of the easel and insert the paper.* The paper should be as flat as possible when the frame of the easel is in place. Remember that the emulsion side of the paper faces up.

STEP 4: *Turn on the enlarger* for the interval of time previously selected from the test strip, then turn *off* the enlarger.

STEP 5: *Remove the paper and slip it into the developer* for precisely the same length of time the test strip took to be developed (probably 60 seconds); agitate gently.

STEP 6: *Remove the paper from the developer,* allowing the excess fluid to drain back into the tray, and place it in the *stop bath* for about 30 seconds.

Fig. 6-12a. Insert a piece of enlarging paper into the easel.

Fig. 6-12b. Turn on the enlarger for the time period previously selected from the test strip.

STEP 7: *Lift the paper from the stop bath* with the second set of tongs and *place it in the fixer.*

STEP 8: After the print has been fully submerged for about 30 seconds, *turn on the room lights* and evaluate the print while it is still in the fixer. The print, however, must remain fully submerged for at least five minutes.

STEP 9: After fixing, *transfer the print to water* where it may be safely stored for an extended period of time. If you find the print acceptable you will finish it later.

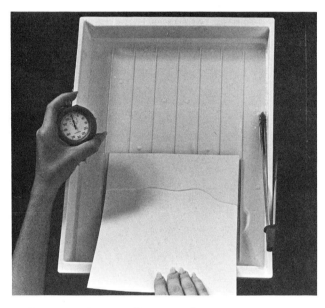

Fig. 6-13a. Immerse the exposed paper in the developer.

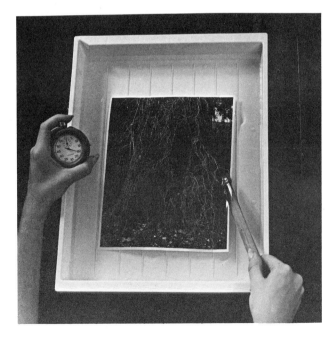

62 Fig. 6-13b. Agitate the paper gently during development.

Fig. 6-13c. Place the print in the stop bath for about 30 seconds with mild agitation.

Fig. 6-13d. Transfer the print to the fixer and let it soak for 5–10 minutes.

EVALUATING THE PRINT

It is a common practice for a photographer to make more than one print from the same negative. It often happens that the first print is too light or too dark, too thin, or too contrasty, and it becomes absolutely necessary to make another print. Don't be alarmed to discover that a good print takes time and a great deal of photographic paper. Some people also like to compose and recompose their prints in order to find the single most satisfying arrangement of elements within the print. Whether a print is good or bad is in large part subjective, depending as it does upon the individual photographer's concepts of composition and contrast. I assume, of course, that all of the correct technical procedures were followed to obtain the print.

Fig. 6-14. This is how the processed print looks.

If you think the contrast quality of the print is acceptable but feel the entire picture was over-exposed or underexposed, then compensate in the next print by altering either exposure time or the f/stop. For example, if the print looks a bit pale, expose the next one for an additional five or ten seconds. If you change to the next larger f/stop, it will have the same effect as doubling the exposure time.

It is sometimes true that no matter how the exposure is adjusted, the print just doesn't look right. This happens when the negative is thicker or thinner than normal. I've assumed, by the way, that up until now your negative was normal in contrast quality and that you have used a No. 2 grade paper. More often than not, if a negative differs from normal density it will be too thin, which may result from either underexposure in the camera or insufficient development of the negative. Depending upon just how thin the negative is, the print may be improved by switching to a higher contrast grade of paper, probably No. 3 or No. 4. Grades 5 and 6 are very insensitive to gray and are reserved for cases of disastrously thin negatives. If your negative is so thin that even No. 6 paper won't compensate, you would be best advised to abandon your attempts to print it.

When the negative is too dense, due to either overexposure in the camera or excess film development, and the print made from it lacks middle values (grays), switching to No. 1 paper sometimes helps. Other than that, unless you chemically reduce the density of the negative (an unpleasantly arduous task using a chemical called Farmer's Reducer) there isn't much you can do.

The various paper grades are not only used to compensate for inadequate negatives, but also serve as a basis for experimenting with many sorts of negatives. Normal or thick negatives printed on No. 6 paper, for example, yield interesting prints almost entirely devoid of gray. In fact, I usually keep a package of No. 6 paper on hand just for this effect.

It really isn't necessary to have every single contrast grade in your darkroom. Because there are only slight differences between adjacent numbers, a representative sample is often adequate, say packages of Nos. 2, 3, and 5. Another assortment might include Nos. 2, 4, and 6. To keep expenses down it's not a bad idea to limit yourself also to two surfaces. I keep a few grades of glossy paper in stock and a few contrast grades of a warm-tone, matte-finish paper as well.

Cropping

I haven't said much about cropping because I don't want to over-emphasize its role in print making. A good print is not one in which a tiny portion of the negative has been isolated and magnified to gargantuan proportions. This practice will make an unattractive print, characterized by excessive grain and lack of contrast. I usually crop for one of two reasons: The first kind of cropping I do might be called "format fitting." The proportions of the negative, even a rectangular one, are slightly different from those of a standard piece of printing paper, so it is necessary to eliminate some of the picture represented on the negative if you wish to fit it to the paper size.

The second type of cropping is to eliminate unwanted or distracting details from the print. These details usually occur toward the periphery of the scene and so the picture quality rarely suffers. Simply as a matter of philosophy, I find it best to keep cropping to a minimum and concentrate instead on carefully composing my pictures at the time they are taken so that I'll save time in the darkroom. With few exceptions, the picture I see in the viewfinder of my camera is the one I want to print. By taking an extra moment or two when I shoot the picture, I save myself a lot of annoyance later on in the darkroom.

Dodging and burning

The two procedures I'll now describe should also

Fig. 6-15a. Dodging is a technique for deliberately underexposing a small area of the print. Here a piece of absorbent cotton is being used as the dodging device.

Fig. 6-15b. It was felt that the subject of this picture was too dark in relation to the background.

Fig. 6-15c. Dodging has lightened the subject while leaving other brightness values unaltered.

be used sparingly, not only because they are "after the fact" solutions, but because they are fairly difficult to use, particularly for the beginning photographer.

If only a small portion of a print is too dark, then the exposure of that localized area can be slightly lessened by "dodging" it. To dodge a print, a small piece of cardboard or absorbent cotton is glued to a wire in the approximate shape of the area to be selectively underexposed, so that the device serves as a kind of shield. When the paper is exposed, the dodging device is agitated gently above this area for a portion of the exposure interval. In this way the overall picture is properly exposed and the localized area is slightly underexposed within the same picture. The movement of the shield is necessary to prevent the formation of a harsh border between the two sections of the print, and to prevent the wire itself from forming an image. The correct exposure times can be established by making two test strips, one for the overall picture, and one for the portion to be dodged. Often, however, one can use a kind of intuitive hit or miss approach to such exposures.

The opposite sort of problem, a small area of underexposure on the print, can be darkened by "burning in" the area. To do this, a piece of cardboard with a hole in the center will be needed. The precise diameter of the hole will be determined by the size of the area to be burned in and the distance of the cardboard from the baseboard. The picture is exposed in the normal way, and then the carboard is placed between the lens and easel so that light falls on the pale portion of the print, but not on the rest of the print. In doing this the small area is given additional exposure while the remainder of the print remains protected. As with dodging, the burning-in device should be agitated gently as it is used in order to prevent the formation of a severe delineation mark between the two exposure areas of the print.

Fig. 6-16a. Burning-in selectively overexposes a small portion of the print. After the local area has been exposed, the entire print is exposed as it normally would be.

Fig. 6-16b and c. (Opposite, top). The light spot in the middle of this print is distracting. Because it is in the negative, it is best cured by burning-in the area during printing. (Opposite, bottom) The corrected print is much more attractive.

66

7
Finishing and Displaying

For people just starting out in photography, the thrill of creating the first few prints may overshadow any consideration of what will eventually become of them. If your pictures are attractive, then you certainly don't want to stuff them into some anonymous drawer or closet only to be viewed by a priviledged few on select occasions. Take some extra time in order to give your prints the substance they require to be displayed.

All prints must be thoroughly washed and dried before any attempt is made to display them. Removing excess hypo from a print is particularly important because the paper fibers retain chemicals more tenaciously than film does. Paper is also more prone to curling and buckling than is film, and special care must be taken to make the print flat so that it can be mounted.

WASHING DEVICES

All black-and-white prints are washed the same way—contact prints, proof sheets, and enlargements. Hypo, that necessary but persistent substance, must be thoroughly removed or the print will eventually yellow or darken. You may not realize the importance of washing until one of your prints turns yellow after two or three years, a most unpleasant experience. A properly washed print, however, will generally outlive the producer of the print.

Because hypo is heavier than water, any washing scheme should allow water to enter above the print and exit beneath the print. Commercial print washers are excellent for this purpose, but they are quite expensive and bulky, and are not in keeping with our informal economic theme. Instead, I'll describe a number of print washing devices, starting from the simplest:

The kitchen sink as a print washer

If you keep one of those rubber-coated wire drainers in your sink, you have all of the equipment necessary for a rudimentary print washer. Simply turn on the water and adjust the drain stopper so that a small stream of water leaves the sink. Allow the water level to build up to a depth of eight or ten inches and then adjust the water

Fig. 7-1a. A simple washer can be improvised by adjusting the stopper in the sink so that only a small amount of water will drain. The wire rack remains in the sink.

Fig. 7-1b. Place the prints on the wire rack and adjust the water so that a constant volume enters and exits the sink.

flow so that the volume pouring into the sink matches the amount exiting. In this way you'll have a constantly replenished volume of fresh water entering the sink, while the contaminated portions are draining from the bottom. Before you place your prints in the sink, make sure the wire drainer is in place; otherwise a print will be sucked into the drain, creasing the print and clogging the

drain. If you can, it's a good idea to swing the faucet over to one side of the sink so that the stream of water glances off the side like a miniature whirlpool, or accomplish the same effect with a short hose extension from the faucet. Because the water level may change slowly over time, it's best to stay in the room and monitor the flow from time to time, and so avert potential disaster.

Fig. 7-2. A "Turbulator" print washer will automatically control the water level and will agitate the prints.

The Dehypo Turbulator Print Washer

A particularly handy gadget is manufactured by the A. J. Ganz Company and is available at many photography shops. It's called the "Dehypo Turbulator" print washer, a fancy name for a special rubber drain cover and tube. The drain cover is made in such a way that water exits at a fixed rate through holes at the base of the cover. Should the water level become too high, a safety drain at the top of the device jettisons the excess amount. At the same time, a rubber hose attached to both the faucet and the side of the drain cover brings water in and shoots it out in a direction parallel to the floor of the tub or sink.

This gadget has several distinct advantages over the cruder method previously described. Because of the safety drain feature, you can safely leave your prints for a few moments without fear of creating a flood. The sprayer tube makes it possible for you to use the bathroom tub if you wish because the fixed-position faucet on most tubs (which would ordinarily cause incoming water to flow directly into the drain) is redirected to make a stream in any direction you like. Using this device, you can process your prints in the bath-

room and throw them directly into the tub, which now serves as a print washer. Print washers should really be large enough to allow water to circulate around the prints, exposing as much surface area as possible, and the tub is a convenient large volume container.

One problem I've found with the Turbulator print washer is that the adapter on the end of the hose doesn't fit every faucet, only those with round cross-sections. Check the faucet you plan to use before you buy such a device.

Fig. 7-3. You can also put the prints in a tray and then place the sink's sprayer arm at one end of the tray. The valve is kept open with wire twist ties.

Tray washers

Several types of washers consist of modified print trays or are attached to print trays. The tray siphon, for example, is an accessory which simultaneously removes water by siphon action as it brings clean water into a tray. A more complex type of washer consists of a tray with a sprayer hose intake at one end and drain hole at the other. The same principle can be achieved by drilling a few small holes (1/8" diameter) at the edge where the shorter side of the tray meets the bottom of the tray. Then tilt the tray in the sink so that water entering the undrilled end will flow downward toward the drain holes. A small object like the print tongs wedged beneath one end of the tray will keep it tilted. Water can be supplied from the faucet, or else from the sprayer attachment common on many kitchen sinks. To hold the sprayer valve handle down, bind it with some adhesive tape or twist ties.

Although trays are convenient, sinks and tubs are preferable because they allow the prints to 69

circulate freely in the water. Prints also tend to adhere to one another in a tray, which restricts washing efficiency and limits the number of prints that can be effectively washed at the same time.

Washing

If you plan to wash your prints in water alone, with no chemical additives present, then wash the prints for about one hour. A wash period shorter than this may not be sufficient to rid the prints of hypo. I've also left prints in the washer for a very long time (in one case, overnight), and the prints lost portions of the emulsion. Be sure to wash for the optimal period, not much longer.

If a water bath is used exclusively, many gallons of fresh water will be consumed as you wash. This is both wasteful, and, if you pay for water, unnecessarily costly. By using a hypo neutralizer beforehand, you will be able to drastically reduce the amount of time the print must be washed, and at the same time be absolutely positive that no excess hypo remains in the prints.

The print is immersed in the hypo-neutralizing solution for a minute or two with mild agitation, depending upon the manufacturer's recommendation. Then the print is washed in the normal manner for about ten minutes. If you don't plan to use a separate tray for the neutralizer, then wash one of your processing trays thoroughly with a liquid detergent and lots of water before filling it with the new solution.

DRYING

Two processes are widely used to dry prints, the blotter book or roll, and the electrically heated print dryer. The blotter book consists of a number of sheets of blotting paper, sometimes separated by waxy sheets. The blotter roll is made of a continuous sheet of blotting paper and a separation sheet, wound together much like a jelly roll. A print dryer usually has two metal plates or a single drum-like plate with an electrical heater on the interior. The plates are covered by muslin sheets held taut by springs.

A blotting book or roll is cheaper than a dryer but prints dried in these take several hours; the dryer is more expensive but prints require only five or ten minutes to dry.

You really should decide at the time of purchase whether you want to use blotters or a print dryer. I mention this because the difference in price between the two is not that great, and once you've purchased a blotter it won't be of much

70

Fig. 7-4a. Remove excess moisture from the print by placing it face down on a smooth surface and wiping the back with a blade-type squeegee.

Fig. 7-4b. You can also use a roller squeegee to remove excess moisture from the print.

value should you later decide to switch to the more efficient dryer method. Although prices are subject to change, at the time of this writing a decent dryer, one which will accommodate four 8" × 10" prints, costs $15 to $20, whereas a good blotter roll is nearly $10. The dryer is so much more efficient, that I'm tempted to recommend its purchase without reservation.

How to use blotters

If you don't have the money or print drying speed is not a factor, then here's what to do. For one thing, don't use a blotter book; always use a blotter roll because a book will deform over time as the moisture from wet prints warps the pages, and the curled pages will impart their shape to the prints. The blotter roll has a corrugated cardboard backing that is wound up with the blotter and helps to keep the blotter smooth. The cardboard's tubular composition also helps air to circulate around the drying photographs.

Fig. 7-5a. To blot the prints dry, begin by placing the first print at the center of the roll, and then work toward the outside.

To use the blotter roll, first remove as much moisture as possible from your prints. This is done by placing the print face down on a clean smooth surface, such as a Formica counter top, and pressing a squeegee over the back of the print. The squeegee may be either the type with a rubber blade such as window washers use, or the roller type, sometimes called a "brayer." Sop up excess water with a clean sponge or paper towel. Then unwind the blotter roll and place the first print face up in the center against the blotter. If there is a cover paper then lay it on top of the print,

roll up all of the layers, and place the next print on the blotter, leaving only a small margin between prints. Continue this process until all of the prints have been positioned. When you complete the winding of the roll, place a large rubber band around the outside of the roll to prevent it from unwinding. To be safe, you should let the roll dry overnight. If the prints are the least bit damp, they will buckle when exposed to air.

Fig. 7-5b. Tie the roll with a string or rubber band and let the prints dry overnight.

One way to hasten the drying process is to place the roll in front of a fan or heating ventilator. The dried prints taken from the roll will have a semi-matte finish if glossy paper was used, or a matte finish if matte paper was used.

How to use a dryer

Prepare the prints as you would for blotting by squeegeeing out excess water. Work with a small number of prints each time, no more than the obvious capacity of the dryer. Take the damp prints and arrange them face up on the metal plates of the dryer, taking care not to crease the photographs as you do this. When the prints have been positioned, secure the cloth cover over the prints. Chances are that your dryer is the "plate" type that can accept four 8" × 10" prints at once. In this case, position and secure all of the prints on the first plate before repeating the procedure on the second plate. The temperature of the heating element is regulated by a single knob on the side of the dryer. I've never discovered what the difference is between low and high temperature in terms of print quality and usually set the temperature control somewhere in the middle. It saves time to turn on the dryer before you're ready to 71

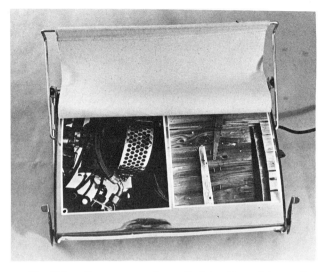

Fig. 7-6a. If you use a dryer, first lay the prints on the plates.

Fig. 7-6b. Close the cloth cover and the prints will dry in 5–10 minutes.

squeegee the prints. Prints obtained from the dryer used as I've described will be semi-matte if glossy paper was printed, or matte if a matte-finished paper was used.

Making glossy prints

Some print dryer instructions tell you that a glossy print can be made by placing the wet print face down on the plates. I've tried this and have always had uniformly ghastly results. In all of my attempts to make glossy prints I have learned one thing: there are no shortcuts.

To make glossies you will need at least one *ferrotype plate* measuring approximately 11" × 17". The plate is a thin sheet of steel coated on one side with high-polish chrome. It helps a great

deal to immerse the prints in a flattening solution or glossing agent, such as Kodak's Print Flattening Solution or Edwal's Super-flat, immediately after washing. Follow the manufacturer's instructions to make the working solution and to determine processing time. Some of these solutions are tricky to use because their effectiveness depends upon the relative humidity in the room. For this reason I use the Edwal formula, which is not dependent on humidity.

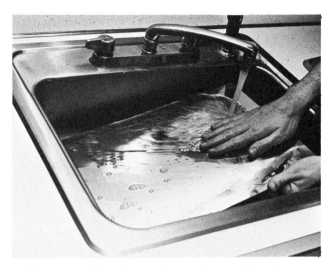

Fig. 7-7a. To make a glossy print, wash a ferrotype plate thoroughly with hand soap and cool water.

STEP 1: Stand a ferrotype plate on edge in the sink and wash the shiny side with hand soap and cold water. *Never* use any sort of abrasive on the plate because even mild abrasives, like those found in household scouring powders, will scratch the plate. When the plate has been thoroughly washed and rinsed, place it still wet on a counter.

STEP 2: Lift a print out of the flattening solution and, without squeegeeing, lay it face down on the shiny surface of the plate. (NOTE: Don't wash the print again once it has been taken from the flattening solution.)

STEP 3: Remove excess moisture and adhere the print to the plate by working a roller squeegee over the back of the print. A blade-type squeegee won't work. Put your weight behind the roller and work from the center of the print outward. Sop up excess liquid with a paper towel or clean sponge. Continue until the plate is covered with prints.

STEP 4: Dry the prints, either by standing the plate on edge against a wall or by placing the

Fig. 7-7b. Roll the wet print onto the plate, working from the center of the print toward the edges. Air dry the plate or else place it on a print dryer.

entire plate on the print dryer. As the prints dry, don't be surprised to hear a crackling noise as portions of the prints separate from the plate.

Any imperfection in the surface of the ferrotype plate will be seen in the finished print. To get rid of tiny scratches (often due to careless handling of the plate), apply a few drops of ferrotype plate polish to the chrome surface. This is a waxy chemical which fills in the scratches and restores the gloss of the plate. To use plate polish, first wash the plate with soap and water, rinse in cold water, and sprinkle four or five drops of the polish on the wet plate. Then polish the plate with a dry cloth (cheesecloth is good), always polishing in the same direction, until no trace of the polish remains.

Prints that have a greasy or oily appearance are fairly common when you first start ferrotyping. This appearance is caused by residue from chemicals in your water or finishing chemicals which have dried on the plate. A complete and thorough cleaning of the plate should be sufficient to restore the surface. In fact, it's best to clean the plate immediately before every print is applied, even if this means cleaning the plate a dozen times during a drying session.

MOUNTING

Mounting refers to a procedure for cementing the finished and dried print to a rigid surface, usually a piece of thick cardboard. This is the one step which, more than any other, can transform a print from the mundane to the extraordinary. Yet it can also be one of the more frustrating experiences of an otherwise promising photographic career.

Photographs may be either "wet mounted" or "dry mounted." Wet mounting uses a liquid adhesive that is applied directly to the back of the print before it is pressed against the backing board. In dry mounting, a sheet of special dry-mounting tissue (which resembles waxed paper) is placed between the print and backing board and heat is then applied to the combination of materials under pressure. Briefly, wet mounting is worthwhile because it is relatively cheap and can be done at home with little or no special equipment. Dry mounting is more permanent than wet mounting, but requires additional equipment.

Basic materials

All cutting should be done with a sturdy razor knife, such as a carpenter's knife, and a metal straight-edge or ruler. The knife can be purchased at most hardware stores and some art supply shops. Metal rulers (never wood or plastic because a knife will gouge them) can be purchased at drafting or art supply stores.

The mounting board is available at many photo supply stores, but art supply shops are frequently cheaper for the identical product. The board itself is called "mounting board," "mat board," or "illustration board," and consists of a layer of thick cardboard finished on at least one side with high quality paper. Don't confuse mounting board with so-called "poster paper" or "oak tag," which is considerably thinner and therefore not good for mounting photographs. It is cheaper to buy mounting board in large sheets and to cut it into smaller pieces than to buy it precut.

Mounting arrangements

You should decide beforehand whether you want any of the board to show in the finished product. Mounts with a border require more work than those without a border, and must be carefully measured to be certain the picture is not tilted in relation to the surrounding board.

A mounted print without a border is also very attractive, and somewhat easier to make. This type of picture is said to be "bled," which simply

73

means that the picture goes clear to the edges of the board. A bled picture can be displayed handsomely without further work, but a bordered print often benefits from some kind of framing. There are no rules for determining when a picture should be bled or should have a border; it's simply a matter of personal preference.

Wet mounting

If you decide to mount the print without a border, then begin by cutting a piece of mounting board slightly larger than the dimensions of the print. For an 8" × 10" print you might cut a 9" × 11" board. With the leeway in dimensions, positioning the print on the board is not critical.

A number of wet mounting substances are available, but frankly I've not used enough of them to advise you to use one instead of another. Some, like Kodak's Wet Mounting Adhesive, come in tubes and require an applicator, while others, like 3M Mounting Spray, come in aerosol cans.

It's a good idea to spread newspaper over the work surface because mounting adhesives can stain furniture. Do all of the cutting on a piece of scrap wood, never directly on the floor or furniture. To wet mount the picture, apply the mounting substance to the back of the print according to the manufacturer's instructions, being careful not to get any on your fingers or the front of the picture.

Fig. 7-8a. Cut a piece of mounting board slightly larger than the print.

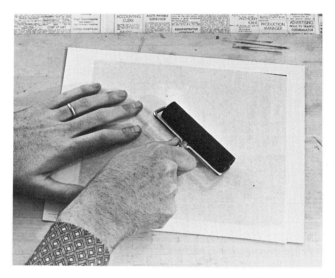

Fig. 7-8c. Place the print on the board and flatten it with the roller. The cover paper is needed to protect the face of the print.

Fig. 7-8b. Spray the back of the print with adhesive.

Fig. 7-8d. When the adhesive has set, trim the print with the razor knife and metal straight edge.

Then carefully turn the picture over and press it to the board, using a roller to smooth out any bumps. The print should be covered with clean paper before rolling, and the brayer should be worked from the center of the print toward the edges. The more recently developed wet mounting adhesives dry very quickly and do not require weighting or clamping of the picture. When the mounted print has "set," trim the board along the white edges of the print with your razor knife and straight edge, making several cuts until the board is severed.

If the picture is to have a border, an easy rule to follow is to cut the board one format size larger than the format of the print. For example, if the print is 5" × 7", make the board 8" × 10"; if the print is 8" × 10", make the board 11" × 14".

Fig. 7-9a. If a border is desired, cut the board one format size larger than the print. Mark the desired location of the print on the board.

Fig. 7-9b. Trim the white edges from the print.

Next, trim the white border from the print and position the trimmed print on the board. There should be an equal amount of board on the left and right hand sides of the print; use a ruler (not your eye) to confirm this. Vertically, however, there should be a little bit more border showing below the print than above it. I don't know why this is, it just seems to look better. Usually, an extra 1/4" of board below the print looks right for an 8" × 10" print mounted on an 11" × 14" board. Mark the position of the print lightly with a pencil, then apply the adhesive to the back of the print. Carefully turn the print over and place it on the board in accordance with your marks. Then adhere the print as you would for a borderless mount.

I think this is the proper time to mention the color of the board. Very bright colors tend to distract the viewer from the content of the print. White, black, grey, or beige are good colors to use. My own bias is to use white board for all bordered mounts, regardless of the content of the picture.

Dry mounting

The problem with most wet mounts is that they tend to be sloppy and some can be affected by temperature or humidity in such a way that the mounted print will separate, buckle, or show ugly bubbles as time passes. Dry mounting is the more permanent type of mounting, provided it has been done properly. Dry mounting can be done at home with an ordinary clothes iron but the success rate for this method hovers around the 50 per cent level. To dry mount correctly, you will need a dry-mounting press which is very expensive and therefore not often purchased by beginners (or many advanced photographers for that matter). Hunt around and try to find someone who will let you use his press. If you work for a large company or college, there may be a press in the graphics department—ask if you can use it. As a public relations device to attract customers, one of the photography stores in my neighborhood lets people use its press. Some stores also rent dry-mount presses at reasonable rates.

To mound a bled print using the dry technique, warm up a common hand iron to a temperature somewhere in the mid-range of the iron's temperature scale. At the same time, heat the press to a temperature of 225 to 275°F., remembering that the press requires five or ten minutes to reach operating temperature. An indicator lamp should tell you when the press is ready for use.

7-9c. After you have sprayed the adhesive and mounted the print, erase the location marks.

Turn the print face down and place a piece of tissue over the back of the print. The tissue must cover the entire surface of the reversed print because the print will only adhere where there is tissue. An 8" × 10" pre-cut tissue will cover an 8" × 10" print exactly. Next, take the iron and gently press a small spot in the center of the tissue so that the tissue sticks lightly to the back of the print. Now turn the print face up and place it on the mounting board. Lift one edge of the print and touch the tissue with the iron so that this edge will stick to the board. If you have done this correctly, the print-tissue combination has now been positioned on the mounting board.

If the press has reached operating temperature, open it and place the tacked print face up in the press. Cover the surface of the print with some clean, unprinted paper, such as brown butcher

Fig. 7-10a. Tack a piece of dry-mounting tissue to the back of the print with an ordinary clothes iron.

76

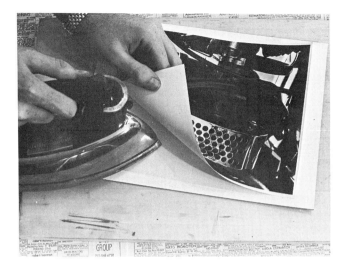

Fig. 7-10b. Tack a corner of the tissue to the board.

Fig. 7-10e. Trim the white print border and excess board.

Fig. 7-10c. Place the materials face up into the heated press with a protective paper over the face of the print.

paper, in order to prevent any residue on the press plate from sticking to the print. Then close the press firmly and let it operate for 30 to 45 seconds. Finally, open the press, remove the mounted print, and let it cool. When the print feels cool to the touch, it can be trimmed with razor knife and straight edge.

When dry mounting a bordered print, tack a piece of tissue to the back of the print and trim the edges of the print before positioning the print on the board. After the picture has been positioned, lift one edge of the print and tack the tissue to the board with the iron. Then place some clean paper over the print and press it as I've just described.

It is very important that the print be made as flat as possible before dry mounting. Some flat-

Fig. 7-10d. Close the press and let it operate for about 45 seconds.

Fig. 7-11a. To obtain a bordered print, first tack a piece of dry mounting tissue to the back of the print. Then trim the white print border and underlying tissue. Continue with the steps for mounting a bled print.

Fig. 7-11b. Erase the location marks.

tening can be achieved by treating the print in flattening solution before it is dried. Double-weight paper also tends to dry flatter than single weight, but sometimes the picture will warp despite all precautions. One way to flatten a print is to put it into the press by itself before tacking on the tissue, or first to iron it. To iron the print, place it on a smooth dry surface, cover the picture side with two or three layers of clean protective paper and run the iron over the print. The iron should be set to the midrange of the temperature scale and ironing should be done from the center of the print toward the edges. The same ironing technique is used when an iron is used in place of the press. The tacked print is again covered with clean paper and the iron is moved from the center of the picture toward the edges. Bear down on the iron this time, but not so much that the iron grooves the print. If a bubble develops while you are ironing, there isn't much you can do to get rid of it. Because so many ironed prints mount improperly, it might not be a bad idea to make extra prints just in case.

DISPLAYING THE FINISHED PRINT

A number of inexpensive but flexible display systems are available to you once the print has been mounted. For example, the mounted photograph can be stuck directly to the wall and will look quite nice. Try to fasten the mount in such a way that no nails or screws show: you might use double-sided adhesive tape or rubber stickums with glue on both sides. Many adhesives, however, will pull strips of material from the wall when they are removed.

To give a mounted photograph more substance, you can attach wooden blocks to the back of the board. This will make the print stand away from

78

Fig. 7-12. Some of the author's photographs in an exhibition. The mounted prints were simply pinned to the cork wall of the display case.

Fig. 7-13. To give the print more substance, wooden blocks can be glued directly to the back of the mounting board.

the wall; the shadows thus created will have a pleasing, framing effect. I recommend that all of your gluing be done with either contact cement or a hot glue gun. Contact cement is just as effective and unquestionably cheaper than the glue gun, but a glue gun is faster and much more fun to use. Whenever you use contact cement, you must remember to coat *both* surfaces to be glued and then to let the glue dry thoroughly. The pieces are always joined *after* the glue has dried. If you have glued wooden blocks or strips to the back of the mounting board, you can even attach a hook from which to hang the picture and so avoid the mess of gluing the picture to the wall.

An even nicer display can be made by gluing a wooden or styrofoam frame to the back of the photograph. The frame can be made of one or

79

Fig. 7-14a. To make a simple frame, begin by cutting four pieces of square molding to conform to the dimensions of the mounting board.

Fig. 7-14c. The glued frame should look like this when viewed from the side.

Fig. 7-14b. Glue the frame to the board with contact cement or hot glue.

Fig. 7-14d. Finish the frame by taping the edges.

two inch square stock, commonly called "square molding." Styrofoam can be cut to these dimensions with a razor knife or saw, or else a solid piece can be used. First, cut a series of pieces to conform exactly to the dimensions of the mounted print. If wood is used, glue the box-like pattern to the back of the photograph with contact cement or hot glue. If you use styrofoam, a healthy application of a white glue, such as Elmer's will fix the frame to the mounting board. Because white glue takes time to set, either weight the frame down or clamp it to the picture with rubber bands. When the framework has dried, a few swipes with some sandpaper may still be needed to remove any rough surfaces. Apply black or white cloth tape or vinyl adhesive (Contact paper) around the edges of the dried frame to finish it.

Fig. 7-15a. In a similar way, a block of styrofoam may be used for backing. First cut a piece to match the dimensions of the mounted print.

Fig. 7-15b. Apply white glue to the styrofoam.

You may want to place the print under a protective coating of glass. Glass offers fine protection from the elements (particularly city soot), but re-flects a great deal of light from lighting fixtures and windows in the room. So-called "non-reflecting" glass can be used, but is more expensive than the shiny kind and blurs fine detail in the print. Glass cannot be applied easily to the frame I've described, but an alternate arrangement is nearly as cheap.

To frame with glass, buy a piece of ordinary window glass (non-reflecting glass if you've come into money) in the exact dimensions of the mounted photograph. The best photographs to use with glass, incidentally, are border mounted, not bled. Cut a piece of corrugated cardboard to match the dimensions of the glass. The side of a box obtained from the grocery store will do this job very well. Sandwich the print between the glass and the cardboard and seal the edges with white adhesive tape, leaving a taped border of 1/4 inch on the face of the glass. If you've used a mounting board with a white border, the tape will barely

Fig. 7-15c. The print can be held to the backing with rubber bands until the glue dries. Finish the edges with tape.

Fig. 7-16a. The elements of a glassed picture: a piece of common window glass, the mounted print, and a corrugated cardboard backing, all cut to the same size.

Fig. 7-16b. Tape the three elements together with adhesive tape, leaving an even margin on the front.

be noticed. In order to hang the picture you'll need a special gadget which is marketed under a variety of brand names, including "Braquettes," "Pic-Frame," and the "Eko Frame Corner Clasp." The device consists of extruded plastic or steel pieces that grip the glassed photograph, and a chain

Fig. 7-16c. Attach the hanging device.

or string under tension between the clips from which the picture is hung. I suppose you could use a glued fabric hanger, but I've never tried one for this purpose and suspect that the glass might be too much weight for the hanger to support.

All of the display systems I've described are desirable because photographs can be interchanged with very little effort. Commercial frames are generally expensive compared to the homemade variety, and are more difficult to switch from picture to picture. I will mention two exceptions, however, in case you have a special picture you would like to enclose in something snazzy. The first of these frames is a type of metal frame, usually steel or aluminum, which comes in sections that are bolted together. Including the cost of glass, an 11" × 14" extruded metal section frame is about $10. But because the frame is so easy to assemble and disassemble, it is a relatively fast process to put a new print in the frame. The frame itself is very sleek and attractive, and the metal finish will not intrude on the subject-matter of the print.

I am particularly fond of a second type of commercial frame which is called the Dax Frame. It is a clear plastic box with a second box made of cardboard nested inside the first. The picture is placed inside the plastic part and the cardboard portion is then inserted to hold it in place. It takes only a few seconds to change pictures, but the initial cost is high compared to the homemade frames. With any type of commercial frame, nonstandard print formats will not fit correctly, so you may have to make your own frame even though you prefer a commercial type.

Fig. 7-16d. The finished print with a glass covering looks like this when displayed.

Fig. 7-17. Commercial frames, like the DAX frame, are more expensive but convenient. The elements of the frame have been disassembled in this illustration.

Fig. 7-18. Several finished photographs in an arrangement with two graphics are shown here.

8

A Mobile Darkroom

In an earlier chapter I gave some suggestions for increasing storage space. Now I would like to describe what I call a "mobile darkroom." In essence, it consists of a large cabinet on casters that stores nearly all of your printing gear, and can be moved from room to room. It also serves as an additional work surface in your "ad lib" darkroom.

Fig. 8-1. The mobile darkroom is little more than a cabinet on wheels.

One of the nice things about this cabinet is that it can be modified to accept a large array of equipment, yet it occupies only a small amount of floor space when not being used for processing. If you are imaginative and the least bit dexterous, you should be able to make this very useful object.

DESCRIPTION

The basic cabinet is little more than a plywood box, partitioned internally, with doors over the compartments. An enlarger can be stored in one

of the compartments, and a simple roll-out shelf can be built to facilitate removing and replacing the enlarger. If you wish, some small items can be stored on the walls of the enlarger compartment.

The remaining processing equipment is stored in the second compartment. The storage chamber is fitted with inexpensive adjustable brackets that can be arranged to accommodate virtually any object you might use.

You may have noticed that chemicals are not stored in the portable darkroom. This is deliberate, because chemicals are the most toxic elements of darkroom work and should be kept in a fairly inaccessible area, such as on a high shelf, where children are not likely to encounter them. In addition, by storing processing solutions elsewhere, you eliminate the possibility of contaminating printing paper from leaky bottles.

The entire cabinet has been placed on ball casters so that it can be kept out of the way when not in use, and moved to the work area when needed. I've found that the cabinet top makes a good work surface for other projects and also serves as a convenient catch-all for books and papers, so in this sense it can be used for more than one purpose.

MATERIALS

In order to build the cabinet you will need plywood, some Masonite for the doors, and small hardware. If you wish to finish the cabinet, you'll also need paint. The following is a list of items for the basic cabinet; the dimensions are correct for my enlarger (a Durst M-600) and for the doorframes of my apartment, but may have to be modified for your circumstances:

Hardware

Four hinges, four large ball casters, four small casters, two magnetic cabinet catches, flat standards and brackets. Paint should be high gloss enamel, white for the cabinet and a bright color for the doors.

Purchasing materials

The plywood should be finished on at least one side. The side facing out should show no knot 85

Fig. 8-2a. With the doors open, the enlarger and supply compartments can be seen. The enlarger shelf is in its extended position.

relationship of most components.

Fig. 8-2b. A closer look at the supply compartment shows the shelving system and door hinges.

holes or fissures, though surface finish for the side facing in is not so important. It makes no difference whether you buy "interior" or "exterior" plywood. The Masonite, which is used for the doors, should also be finished on at least one side, and again the rough side can be faced toward the inside.

Cutting

You may want to buy a full sheet of plywood and cut out the pieces yourself, but this requires some sophisticated tools. It is so important that the cuts be square, that I don't recommend cutting with a hand saw, even a good one. Some kind of power saw will be needed, preferably a circular saw.

If you aren't very adept with tools, it would be best to have the man at the lumberyard do the cutting. Most lumberyards charge for cutting, but they do an excellent job and can save you a great deal of annoyance. There are real price difference between different lumber suppliers, so it would be a good idea to compare before making your purchase. The cost of the lumber, including cutting fees, should be about $15.

CALCULATING DIMENSIONS

As I've already suggested, the dimensions of your cabinet should reflect two measures: the width of doorframes in your house, and the size of your enlarger. A heavy cabinet does not always roll along as smoothly as you might suppose, so allow a minimum of one-half inch clearance on either side of the cabinet. When making this calculation, be sure to take into account any moldings on doors that extend beyond the box-like structure of the cabinet.

The compartment that houses the enlarger should also have built-in clearances for the enlarger, both on the sides of the enlarger and above it. The one-half inch clearance is an adequate amount of space on either side of the enlarger, but above the enlarger I've found that it's best to allow more room, at least two inches. Because the top of the cabinet will be a work surface, it is advantageous to make the overall height of the cabinet comfortable for working. A height of 30 inches is about right, so the 28 inch high cabinet I've built, with an additional two or three inches for casters, is approximately correct. Fortunately, my enlarger is shorter than this dimension, as are most small enlargers, and it fits inside the cabinet quite comfortably.

Once you've decided the general dimensions of your mobile darkroom, draw a detailed plan of assembly showing the exact dimensions of each piece of wood. Remember to include the thickness of the compartment doors and the edge molding used to finish the rough plywood edges. Check and double-check because this is the stage where mistakes can be eliminated without cost.

1

2

3

4

5

6

Fig. 8-4. These six steps illustrate the assembly sequence of the cabinet.

BASIC CABINET DESIGN

Item	How many?	Material*	Dimensions
Cabinet top	1	plywood	$28\frac{1}{4}'' \times 20''$
Cabinet bottom	1	plywood	$28\frac{1}{4}'' \times 20''$
Cabinet back	1	plywood	$28\frac{1}{4}'' \times 27''$
Sides/partition	3	plywood	$19\frac{1}{2}'' \times 27''$
Enlarger compartment door	1	Masonite	$16\frac{3}{4}'' \times 28''$
Supply compartment door	1	Masonite	$11\frac{1}{4}'' \times 28''$
Edging	—	pine	$\frac{3}{4}'' \times \frac{1}{4}'' \times 72''$

* All plywood is $\frac{1}{2}''$ thick, and all Masonite is $\frac{1}{4}''$ thick.

CONSTRUCTION

You will need glue and finishing nails to assemble the pieces. The glue can be the white liquid type or hot glue (contact cement won't hold well on plywood edges). The best nails to use are "finishing" nails because they have no heads to mar the finish of the completed cabinet. If the nails are too short they will pull out, so use a $1\frac{1}{2}$ inch nail. The nails should always be driven at a slight angle from the vertical, which helps to increase their holding power.

Here are the steps to follow in assembling the cabinet:

STEP 1: Draw a line across the top piece where the center partition will be located. This line represents where nails will be hammered. Repeat the process on the bottom of the cabinet so that you will know where to locate the center partition. The top and bottom should also be marked with a line 1/4 inch in from three of the edges as a nailing guide for the sides and back.

STEP 2: Tap in four or five nails along one of the short edges of the top piece at equal intervals. Don't go through the wood, just hit them hard enough to hold.

STEP 3: Apply a bead of glue to the edge of one side piece, and line it up with the top piece edge. Now hammer in the nails to join the two pieces. If you have done this correctly, the side will be flush with the forward edge of the top, but a 1/2 inch space will occur at the back where the back piece of the cabinet is to be secured.

STEP 4: Join the second side of the cabinet to the top with glue and nails. If glue should spurt out, wipe it up with a wet cloth before it dries.

STEP 5: Turn the sides-and-top assembly over and nail on the bottom piece. Take your time. If a nail goes in crooked don't be alarmed, just remove the nail and try again. The hole can be filled in later with wood putty.

STEP 6: Carefully center the partition along the nailing lines you drew in the first step. Nail in the partition and check to be sure that the compartments are squared.

STEP 7: Turn the assembled portion of the cabinet so that the edges along the front side rest on the ground. Apply glue to the exposed edges of the side pieces and the center partition facing you. Then position the large back piece and nail it to the edges and the center partition. Finally, secure the top and bottom sections to the back piece along the edges. If the assembly has felt wobbly until now, it should be quite rigid after the back piece has been nailed in place. Allow the glue to dry.

The method of construction I've described should be adequate for most circumstances, but the possibility exists that joints could separate with time. You may wish to install screws in place of some of the nails, or you could dowel the joints. The first alternative is somewhat simpler, so I'll describe it briefly. Use $1\frac{1}{4}$ inch flat-head wood screws. Wherever you want to apply screws (three per edge is about right), first drill a pilot hole

89

with a 1/16 or 3/32 inch drill bit. If you are a real woodworker, countersink each hole so that the screw heads will be hidden beneath the surface of the wood.

Fig. 8-5. Molding is an effective means for hiding the rough plywood edges.

Edging

Plywood is reasonably priced and strong, but the edges of the sheets are rough and untidy in appearance. There are a number of ways to hide the edges. The simplest way is to glue or nail molding to the edges. The kind of molding you will need measures 1/2" × 3/4" and comes in six to eight foot lengths. Measure an edge, cut off the same length of molding and fix it to the edge. Continue this until the edges are covered. If you have decided to add molding after the cabinet has been assembled, you will not be able to finish edges that abut one another without destroying the squareness of the cabinet. In the cabinet shown here, for example, only the front edges have had molding applied.

Instead of molding, you might try edge tape, which is nothing more than a long roll of wood veneer. The veneer is glued to the edge with white glue and trimmed with a razor knife when the glue has dried. Edge tape is more difficult to use than molding, but doesn't add to your calculations, so there's no need to compensate for its thickness.

Sometimes an application of spackling compound is sufficient to finish the edge. Spackling

is a plaster-like substance which comes pre-mixed in cans and handles like soft clay or putty. To use it, apply a generous layer with a spatula and let it dry. The edge should then be sanded smooth, although it may be necessary to repeat the spackling until the edge is thoroughly coated. Spackling is cheap and looks quite nice, but it isn't terribly strong and may chip.

Finishing and painting

The finished cabinet will look best if you first sink all of the nail heads beneath the surface of the wood with a nail set or punch. The tiny depressions can then be filled in with putty or plastic wood and sanded. The cabinet should be thoroughly sanded before being painted. Begin with a medium grade of sandpaper and work down to a fine grit in successive stages. Always use a sanding block if sanding by hand, or a belt or oscillating sander if you prefer an electric sander. Sanding disks, like the ones that mount in electric drills are not good for finishing because they leave coarse circular marks.

I've found it easiest to paint with a high gloss enamel (like "Red Devil") applied with a roller. It may take two or three coats before the cabinet acquires a smooth finish. If you think the top will be subject to a lot of wear and tear, then it might, be advisable to cover it with linoleum.

Mounting the doors

You can use door pulls or cut-out hand holds in order to open and close the doors. The openings

Fig. 8-6. The shelf in the enlarger compartment moves on four small furniture casters.

Fig. 8-7. The mobile darkroom will expand limited counter space in the improvised darkroom.

shown here were cut with a coping saw and finished with a file; the doors are kept closed with cabinet catches. Hinges were attached to the edges of the cabinet and then their position was marked on the doors. Holes were drilled in each doors, and nuts, bolts, and washers were inserted to secure the doors in position. It may be necessary to sand the edges of the doors after they are mounted in order to make the space between the doors even. Finally, the doors should be painted with a contrasting enamel.

Shelves

The equipment storage compartment contains a series of adjustable shelves. The interior of the compartment has four standards screwed onto the walls and small clip brackets fitted into the standards; the shelves are placed to divide the area into a number of smaller compartments.

The enlarger sits on a sliding shelf rather than on the floor of the cabinet. The shelf was made by hammering four small furniture casters into the bottom of a board. The enlarger can then be moved part way into and out of its compartment without banging against the sides.

MODIFYING THE CABINET

Because this mobile darkroom is designed so simply and can be assembled so easily, you may wish to customize it for your own special needs. For example, you might add a counter top that either rests on the top of the cabinet or folds flush with one of the sides and in this way expand your counter space. An electric timer might be incorporated in the top of the cabinet or else mounted in the enlarger section. There's still a great deal of room in the enlarger compartment for mounting small objects, like tongs, against the compartment wall.

If you don't have to move the cabinet around, you can, of course, eliminate the wheels. For example, I know someone who uses a darkroom cabinet similar to the one described here, but in a closet. When he wants to print, he just pulls a few things out of the closet, sets up his enlarger and goes to work.

Index